DEVELOPING VISION & STYLE
A LANDSCAPE PHOTOGRAPHY MASTERCLASS

Joe Cornish • Charlie Waite • David Ward • Eddie Ephraums

ARGENTUM

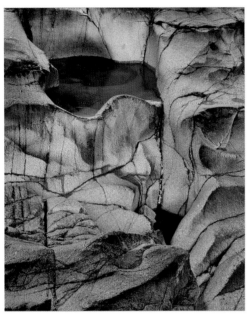
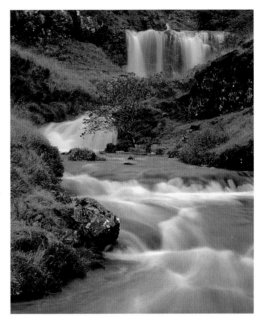

Jon Brock [p122-123]

How do we define our vision and style? Can we? Should we? There appears to be no single answer. EE

Finding our vision

How do we create a style of our own?

Edited by
Eddie Ephraums

The art of the 'possible' becomes evident if one looks behind the images that others create. PK

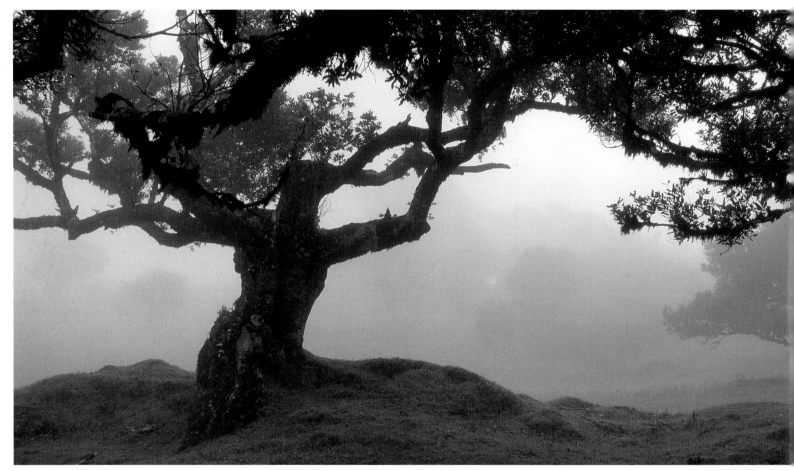

Laurels in the mist
Peter Karry [p147]

LONDON BOROUGH TOWER HAMLETS	
C001541619	
HJ	14/01/2008
778.936	£20.00

VIEWPOINTS

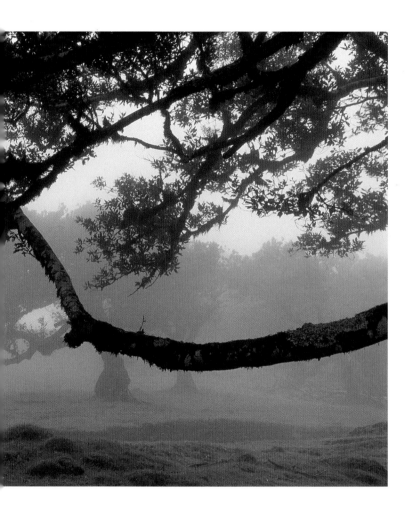

WHAT'S YOUR VIEW?

Eddie Ephraums

A debate on vision and style

We all have something special to say and photography is the way many of us choose to express our views. But, amateur or professional, how do we 'speak' in a way that is unique to us? How is it that we develop our own personal approach to photography?

It's a challenge (and a very enlightening one) to define what makes one photographer's work stand out from another's. It is harder still to describe what makes our own images unique. How do we decide, as our photography evolves (which it will), and we take 'better' pictures, what it is that makes them better than our earlier work? Success can be so hard to define (let alone achieve) – especially if we haven't clarified our intentions, articulated our ambitions, or figured out how we wish to realise them photographically. One of the aims of Developing Vision & Style (DV&S) is to explore these ideas, so that we can continue to grow creatively and to express ourselves even better.

To assist in this process, I asked Joe Cornish, Charlie Waite, David Ward and aspiring photographers to share their thoughts on developing an individual approach to photography. I felt it was critical to such a discussion to start with a set of questions that addressed the main issues around vision and style, and to ask all these participants to answer them in their own way. These questions and my thoughts on their replies can be found overleaf, on page 8.

What makes DV&S unique is not just that the participants shared their thoughts (and most eloquently), but that, by taking part, they have subjected themsleves, their views and their images to critical analysis. As the editor, it has been my job to decide which of their pictures or what parts of their text (if any) to include. Does my selection process mean there are winners and losers – that some pictures or viewpoints are necessarily better than others? No. This book tells just one of many possible stories and it has its share of sub-plots, too. Joe, Charlie and David may be described as the authors, a role for which their experience and authority equips them, but one of my intentions was to demonstrate that every aspiring photographer has equally important views to share. You'll notice the contributors are credited next to their images and each part of their discussion.

As the sub-title says, DV&S is a Masterclass. Such a class can only happen if people take part. Without their participation, or yours as the reader, or mine as the editor and designer, a book like this, or its critically acclaimed predecessor Working the Light, could never be created. My decisions about what photographs to include and which viewpoints to quote are expressions of my (editor's) vision and my (design) style. As a photographer I have shared my viewpoint, too – on the website. The vision and style debate continues at:

www.developingvisionandstyle.com

Swirling leaves
Mark Sunderland [p147]

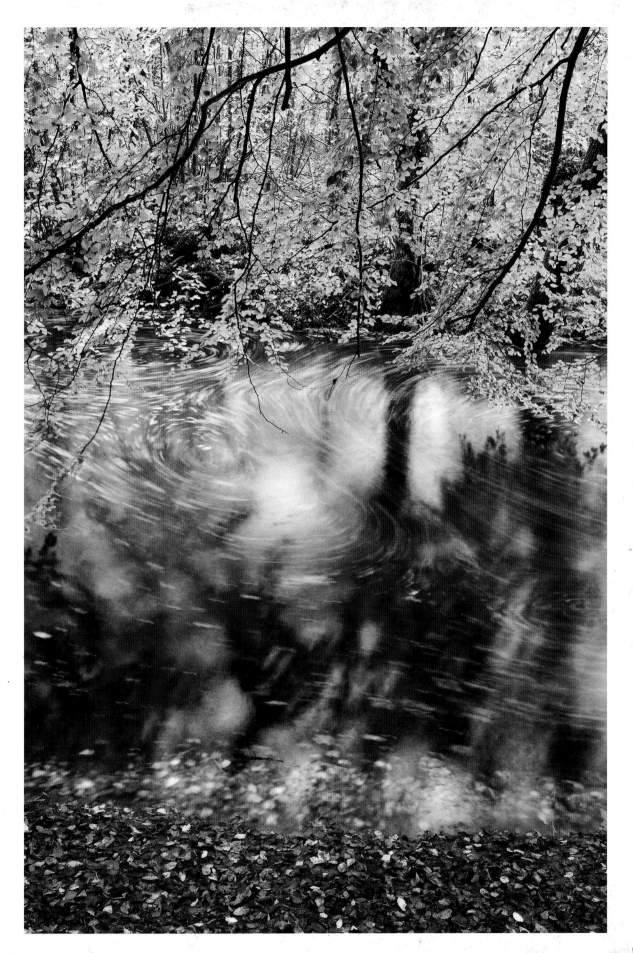

Questions about vision and style

TO START THIS OPEN DEBATE, I asked the three authors and those who chose to participate, to address a range of questions, outlined below. There were no restrictive rules about what to write (a matter of personal vision), or in what way (style) people should respond – only that everyone should have a go! Entrants were also invited to submit up to six pictures that they felt reflected their approach to making pictures. This book is the product of their incredible efforts. Even more viewpoints can be found on the website.

THE VIEWS PEOPLE HAVE EXPRESSED are strikingly varied and sometimes quite unexpected. Participants spoke of their hesitation at articulating what vision or style was about ('Isn't it the viewers' job to decide?'), but bravely went on, often to describe how the process of writing had really helped them clarify their approach. Others found that this got them to see that the six pictures they had selected were, perhaps, not as representative of their vision or style as they had first thought, or that their vision had moved on and their pictures no longer reflected where they were headed. Many entrants described how the process of selecting six images to address a specific context, gave them a more focused and critical eye. Also, they spoke of how it enabled them to discover previously unnoticed aspects of their work, and how they learnt from this experience. Who would say vision or style don't evolve – consciously or otherwise? I could continue, but it's the entrants' turn now and time to give you a chance to reflect on their viewpoints – written and photographic – both in the book and at www.developingvisionandstyle.com.

HERE ARE THE QUESTIONS they addressed:

What does vision mean to you?
How would you describe your vision?
What is it based on? Is it evolving? If so, in what way?
How do you try to convey your vision through the pictures you make?

What does style mean to you?
How would you describe your style?
Is your style evolving? If so, in what way?
Might style enhance or limit creativity? If so, how?

Has digital photography affected vision and or style?
If so, has it been for the better or the worse?

What can we learn from the looking at the work of other photographers?

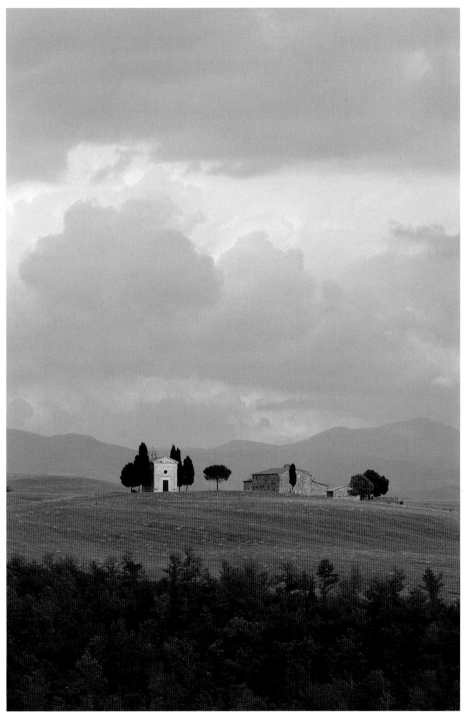

Vitaleta
Angela Baldwin [p147]

THE SUBJECT DECIDES

JOE CORNISH

We bear witness to what we have seen. What we choose to photograph, and how we photograph it says what we think, feel and believe about the subject, about the world and about ourselves. Our photography is the world made visible through the lens of our soul. JC

Cir Mhor, Arran mountains
Joe Cornish

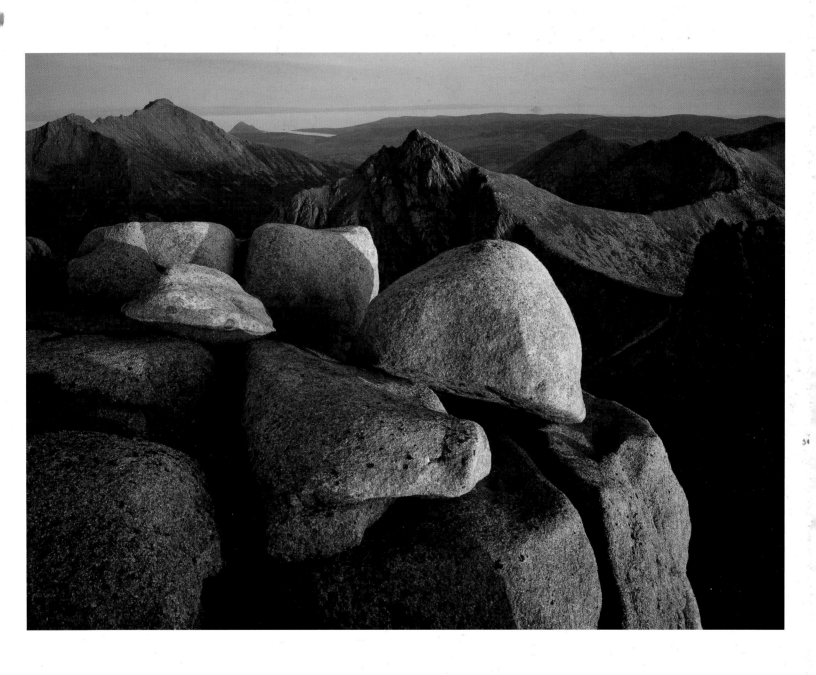

Joe Cornish

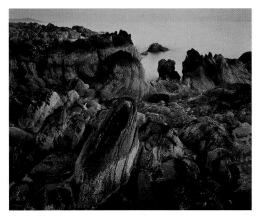

Imacher Point, Arran

I visited Arran with my parents in 1978 while still an art student, as I was first falling tentatively in love with landscape photography. While driving the west coast road we had stopped at Imacher Point, and I photographed some twisted and weathered metamorphic rocks. Later I made a print, and wrote in pen directly on the print, in a naïve art student fashion, contemplating the nature of geological time. On the day of my father's funeral, not long ago, I rediscovered that print in a frame on the wall of my cousin's house. It was a vivid moment of connection, for it was my father's love of Scotland that had led me to Arran in the first place. I still visit Imacher Point, sometimes alone, sometimes with a workshop group. It is a sensational piece of coast, offering in a compact area an infinity of possibilities. California has Point Lobos, Arran has Imacher Point. Here, I worked in twilight, aiming to let the afterglow reveal rock as a living thing.

MY VISION LOOKS OUTWARD more than in. I allow the subject to dictate the terms of approach and composition, and look to make lighting an inherent quality of the moment and the image. My vision is based on a belief that the subject matter is the main thing, as opposed to the photographer. Hope, and a faith in life and nature, guide my use of light and composition. I seek to express a sense of wonder, and capture the joy that the landscape inspires in me. My vision evolves, reflecting my desire to improve and grow as a photographer. This informs my approach photographically and will also affect my choice of subject matter. But I am not interested in being 'cool', up-to-date, or fashionable.

IN A SENSE MY VISION is the pictures I make. My photography and my vision are one and the same thing. Garry Winogrand said he photographed things to see what they would look like as a picture. I photograph to find out what I am really seeing.

IN TERMS OF PHOTOGRAPHY, I acknowledge that I may have a style, because people are always telling me they recognise it. But I have never sought style in itself. I regard it as simply a by-product of my vision.

There may be a perception that my style is 'lots of foreground (probably with a big boulder), dramatic sky', but anyone who has taken more than a passing interest in my photography will realise that this is a very crude over-simplification. Rather, I would hope my style reflects my belief in the interconnectedness of things, and a fascination with depth, and space, and texture, and light; and an overriding belief that composition (like life) is a question of balance.

I am aware that I still love to photograph the same sort of places that I loved when I was a child, especially if they are by the sea. If there is a stylistic evolution it probably reflects the fact that I am now more willing than I once was to take risks with the weather conditions. So now when the light is flat or overcast, or if it is raining or windy, I am much more likely to have a go at picture-making than I was a few years back. It reflects the idea that real weather, be it 'good', 'bad' or indifferent, should be a part of my work. David Ward extols the virtue of adapting our photography to the prevailing lighting conditions. I am trying to put that lesson into practice.

Urra Moor, misty dawn

Much of my life in landscape photography has been spent trying to capture the detail and surface texture of my subject matter. I love the physicality of large-format photography, its ability to reproduce this abundance of visual information, and I have revelled in it, developing my technique and approach to exploit this capability. But in so doing I have sometimes lost the bigger picture, the broad brush of light and shade, and the theatre of light which attracted me so much when I first got into landscape photography. So I have made a conscious effort to stand outside my comfort zone occasionally, and make pictures that work not because of detail and literal information, but because of the light and the moment. This image, shot with a standard lens and a combination grad filter as I descended from Hasty Bank after dawn one morning, is one of those. Exposure-wise it was incredibly difficult to judge. I made four exposures (extravagant), all give slightly different impressions, but this is (marginally) my favourite.

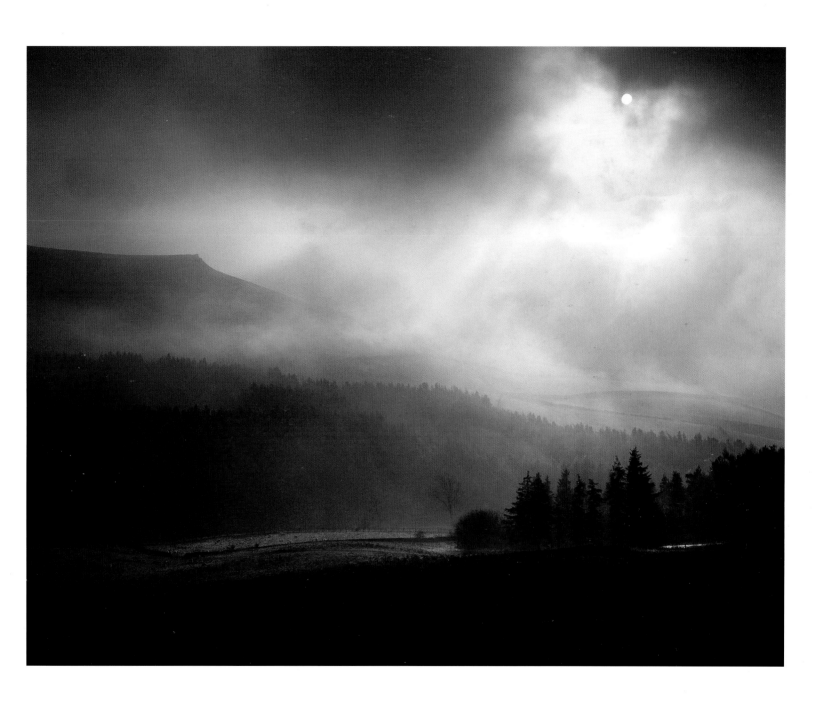

Photographic vision means seeing, as opposed to merely looking. This seeing is informed by photographic technique and camera choice; by our aesthetic and cultural background; and finally by the mind, the heart and the soul. Vision reflects what the photographer truly thinks, feels and believes. JC

Digital photography has widened the range of photographic possibilities enormously, but has also promoted sloppiness and 'auto-dependency' on the part of many photographers, which has done nothing for their vision and style. Unquestionably, in sports, wildlife, portrait, fashion and special effects photography digital has been a great leap forward for creativity. JC

I THINK THAT STRIVING for a particular style could limit creativity by inhibiting an open mind; yet it could also enhance it by creating a clear aesthetic framework. However, I doubt whether the pursuit of 'style' as such is justified in my own landscape photography. I feel that would be the photographic equivalent of putting the cart before the horse.

IN MY BOOK *First Light* I acknowledge the influence and inspiration of seven photographers, in the chapter, 'Friends and Heroes'. (Two of those photographers are my collaborators here, David Ward and Charlie Waite.) There are many others beyond the seven covered in that chapter whose work has inspired me, and many non-photographic artists also.

Perhaps the single most important influence in recent years has been the late Peter Dombrovskis, a Tasmanian wilderness photographer, whose quiet yet passionate images work for me on many levels. His work is, in a way, the repudiation of style for style's sake. On the contrary, it is a celebration of the subject matter, pure and simple. His best work makes the photographer invisible, focusing our attention totally onto the colour, texture, shape, form and vitality of the wild landscape he loved so much.

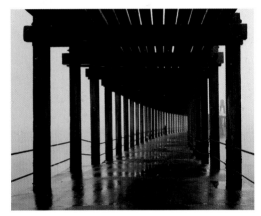

Below the boardwalk, rain
The large-format camera lends itself perfectly to photographing architecture and structures, and I have shot the wonderful curving breakwater piers that shelter Whitby's ancient harbour on many occasions. Recently, the local authority has restricted access to the lower decks, but before that happened I went down there one day when it was pouring with rain. I had an hour before I was due to leave, and, out of curiosity and to test my new monopod-mounted-umbrella-lashed-to-my-tripod rig, I made this photograph. There were no mid-tones, no colour, just monochromatic form, and line, and perspective. Through very careful camera positioning it all worked. Just.
The test of the rig worked a treat, and the context was that the National Trust photo library had asked me to photograph extremes of weather (from heavy downpours to the cracked bed of a dried-up stream) to illustrate the pressing issue of climate change. Photographing bad weather taught me that there is probably no such thing as bad weather, photographically, but rather an unwillingness to solve the problems it presents. Learning to shoot in the rain has taught me to see photographic opportunities I had never considered before. And because I have always believed in the documentary tradition in photography, I want to document all conditions, not just those we, socially, consider 'fine'.

Traigh Eais
In my book *First Light*, I said that light was the first (and the last) consideration when photographing landscape. Now my approach may have become more flexible, but I am still very conscious that the sky, which is after all the source of our landscape light, should be an integral part of the composition. What pleases me about this image, made on a deserted beach on Barra in the Outer Hebrides, is the almost perfect fulfilment of that principle. In the fading light of a summer afternoon I was struggling to make a composition that was interesting enough. The beach itself is beautiful in a very simple way. But perhaps too simple. The shape of a cloud in the distance held some promise and I set up my camera and wide-angle lens with the curving pool and drainage channel more in hope than expectation. Suddenly, as it moved rapidly from west to east, the cloud began evolving into a perfect echo of the pool and channel. There was no music, no fanfare, but for a few minutes I was in a state of intense concentration, trying to ensure that I captured what I knew was an unrepeatable mystery, a gift of light, when for a brief spell the beach and the sky danced a perfect rhythm. Sometimes you get lucky.

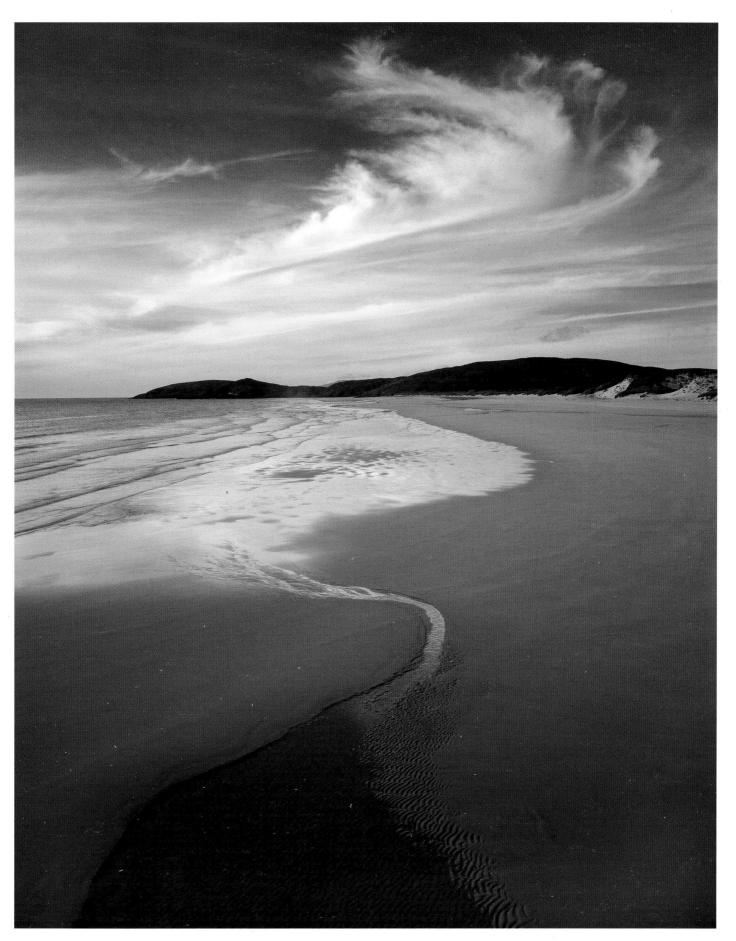

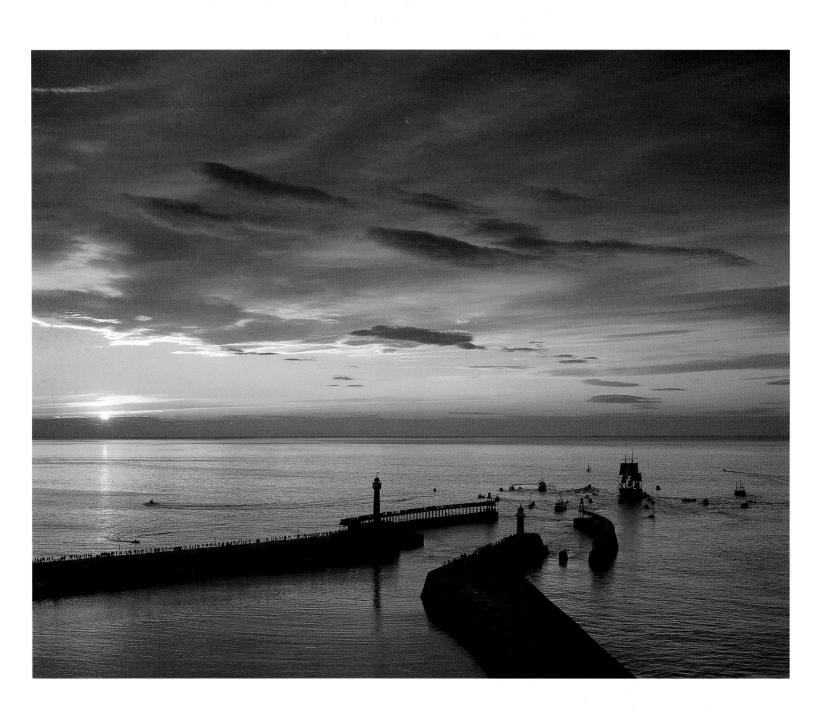

By studying the work of other photographers we can learn that the best work comes from being true to our personal vision. JC

I think it is very difficult to describe your own style, for we are too close to be objective about it. In all honesty, although lots of people have said to me 'I love your pictures' (thanks very much), no-one has ever properly described my style to me. JC

CHARLIE'S WORK FROM THE LATE 80S had a huge impact on me. I followed the trail he blazed in travel/landscape photography books, and it was hard for me to escape his influence and find my own voice. All too often I found myself trying to make pictures like his. Needless to say I failed hopelessly.

His images from France and Italy particularly – there are too many to single out individual examples – remain classics of their kind. He captures moments where the sky and the landscape merge into one perfectly ordered canvas of light, a sort of Claude Lorraine for our time. It is no wonder his work is often likened to landscape painting.

David's work is of a completely different genre, and is still in a sense in the crucible of its own evolution. His pictures are not like painting, but are purely evolved from photographic technology, and are ahead of their time. He has his own take on creation. His pictures are both beautiful and often disturbing in that they apparently defy scale, forcing us to question what we are seeing. They are about ambiguity and unexpected juxtapositions of tone and colour, texture and light. In this way he is often able to transcend the limitations of the subject matter, yet he does so through 'straight' photography, on large-format colour transparency film. Again, I would not wish to single out specific examples. But I can think of many instances when he and I have been shooting together, or at least in the same area on the same day, when my efforts may have worked in a fairly predictable way, but David has discovered some strange new world!

Endeavour leaving Whitby

At the time I make a picture my attention is devoted to seeing the composition and, through timing and lighting, fulfilling the idea as powerfully as I can. Thoughts about where the idea comes from are buried in the subconscious, and it's difficult to know in retrospect whether the associations a picture has for me are authentic or, to a degree, wishful thinking. Nevertheless, this image is for me a reminder of three heroes. They are J.M.W. Turner, painter, James Cook, pioneering sea captain, and Frank Meadow Sutcliffe, photographer. Whitby was Sutcliffe's home for most of his life, he would have known this view intimately, and the endless artistic potential he found in the tiny area that then made up Whitby's harbour, streets and cliffs remains an inspiration for me today. Cook, a towering figure locally, and nationally too, is commemorated in the photograph, by the replica of his ship, the *Endeavour*. Nowadays, none of us can truly experience the discovery of landscapes and continents as he did, but we can be amazed and inspired by his leadership, bravery and willingness to accept risk (a key component in developing artistic vision). Finally, J.M.W. Turner's painting, *The Fighting Temeraire*, is one of my favourites, and a three-masted ship silhouetted against a spectacular sunset is, for me, bound to be resonant of this painting, a high point in romantic art (the painting is also charged with an element of political scandal). Britain's greatest ever painter was, arguably, the first to judge light a subject in its own right. Had he been alive today, therefore, it is interesting to speculate which would have appealed to him more: painting or photography.

Low Newton, dawn.

I believe in the interconnectedness of things. And while that synergy may be more easily encountered in nature, I think that manmade things and natural forms can also have a visual harmony. Here, the elegant curves of the dew-covered grasses relate to those of the kayak, which enters stage right so to speak. As a keen sea kayaker, these boats mean adventure and freedom to me, and while I don't think this image necessarily speaks of that, I feel a strong empathy for these boats. This subdued sunrise, heralding a beautiful day on the Northumberland coast, was still soft enough to shoot into, but within a few minutes the sun was too strong, and the moment passed.

'THE SUN IS GOD' were allegedly J.M.W. Turner's dying words. If he was right then to us landscape photographers, clouds are surely His (sometimes unruly) angels, or courtiers, doing His bidding, buttering Him up and generally making Him look good. Frequently they conceal Him from us altogether, reminding us just how much we miss Him when He's away. JC

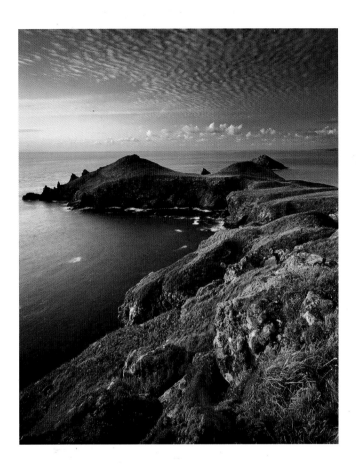

I was contacted by the art editor of a digital photography magazine recently. He was in search of landscape pictures for a cover. When I pointed out I was still a film-user, and so perhaps didn't qualify, he replied that the majority of their covers were still shot on film due to the lack of high quality digital photographs to choose from. To put it mildly, I found this statement quite astounding. I can see no obvious reason why digital should not be as applicable to landscape as to other photographic genres. JC

Rumps Point

I brought an Ebony 45S in 1993, while I was still in London. In theory it was to help me in my quest to become a landscape photographer. In practice it did, eventually. But what with one thing and another it wasn't until 1995 that I took my first landscape photographs with it, in the evening on a site overlooking Rumps Point in North Cornwall, a place I know and love, with strong childhood memories. In spite of the (relative) success of this clifftop effort, it wasn't until October 1997, when I spent a week with it in Père Lachaise cemetery in Paris, that I started to photograph regularly with the Ebony outdoors. In time, I would acquire a smaller, lighter Ebony (SW45) to complement my wide-angle lens preferences and my desire to carry less weight. But the loan of a sophisticated 45SU in 2002 provoked a purchase of this model, one tweaked slightly to my own specs. It is the camera I still use on an almost daily basis, and, inherently flawed though any wooden camera is, I find I that its use has become second nature; it allows me to focus (metaphorically as well as literally) on the subject matter better than any other camera I know.

New Roseberry bluebells

I try to photograph in the landscape regularly as, like a musician or an athlete, I feel that practice (or training) are important both physically and mentally. My 'homeland-scape' is Roseberry Topping, the hill that overlooks our village, and I know I am lucky to live with such a charismatic landmark nearby. My collection of pictures of it is so large that, along with the village community archaeology group, I was able to publish a book devoted to the Topping in 2006. These views of Roseberry may include the peak in the distance, but the majority of the picture is usually filled with trees, flowers, rocks, moorland, drystone walls or other elements of the varied country that surrounds it. It is the fascinatingly varied aspects of the landscape I seek to interpret, while Roseberry is simply the Topping on the compositional cake. Bluebells are a highlight of the year on the slopes beneath the Topping, and though I have photographed them numerous times I am still motivated by a desire to do it differently, and hopefully better, than I have in the past. This is my latest version. There is a slight problem now though. Every time I walk here on a fine evening at this time of year I invariably find that among the bluebells the landscape is blooming with fellow photographers, their cameras and tripods!

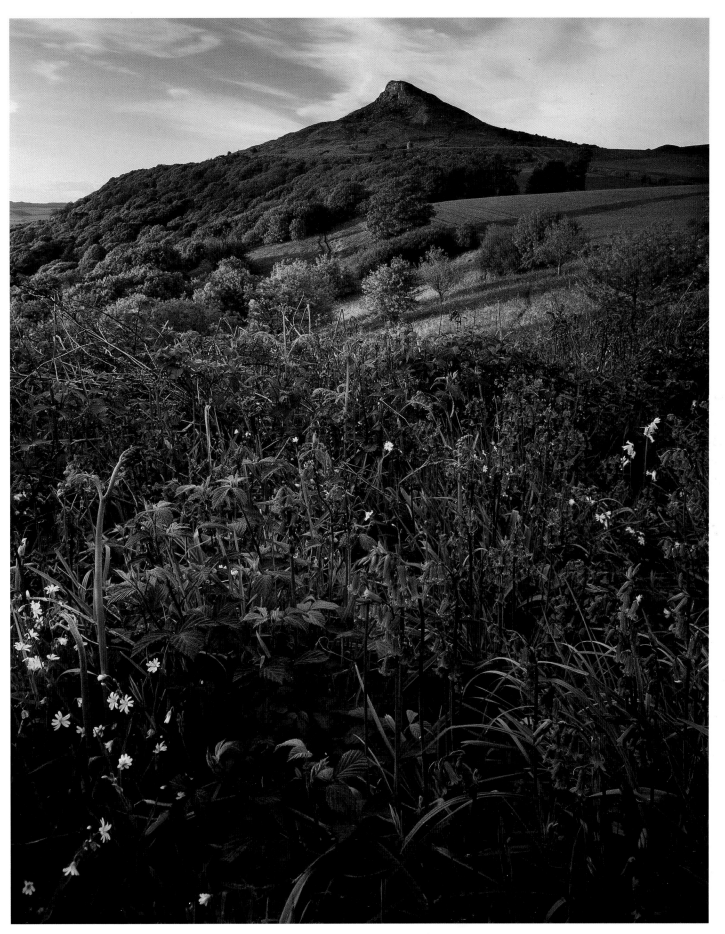

GALLERY FORUM – 1

Photographers discuss vision & style

Style constantly evolves because you find new photographers or influences that affect you and the way you see the world. If it stops evolving then you've got yourself stuck in a rut. Each photograph becomes a copy of the last, simply in a different location. Style can limit creativity if you don't allow yourself to break your own rules. You should constantly be pushing the boundaries and trying new approaches or ideas. Tamara Kuzminski

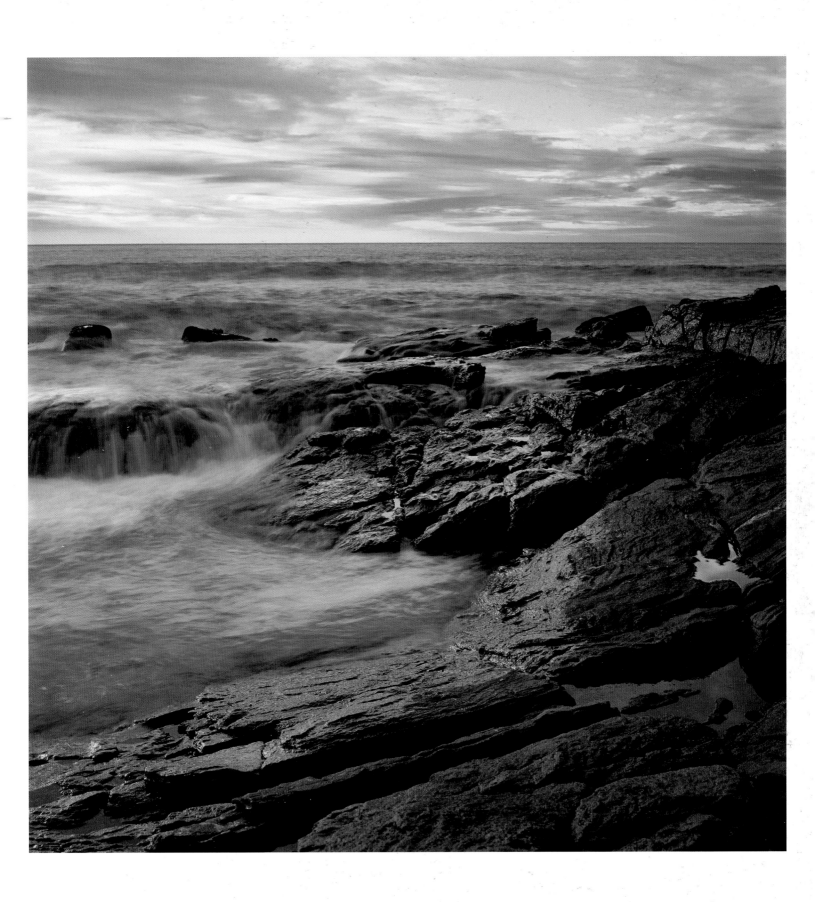

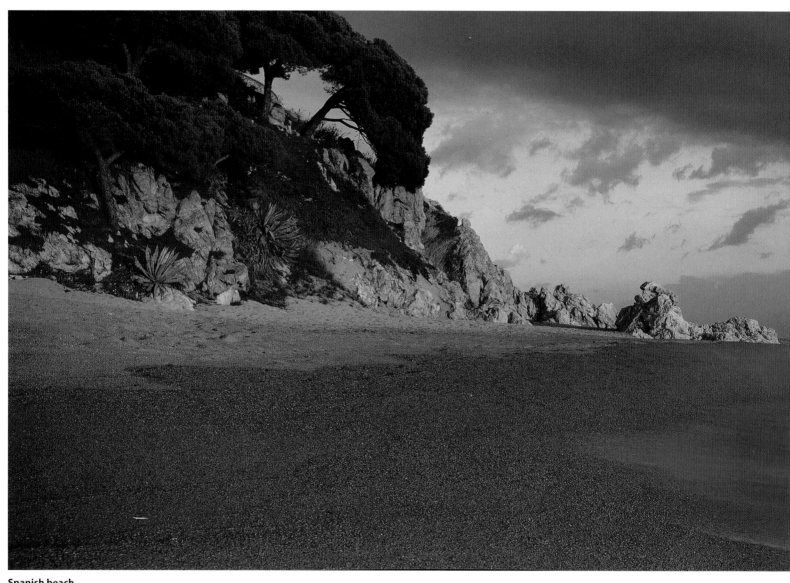

Spanish beach
Nigel Baker [p143]

Nigel Baker

Vision is a way of seeing and representing the world through our own eyes. It is something we acquire in the course of our own photographic journey rather than copying from others. My vision is evolving, it is based on my choice of photographic format, which is influencing the way I see. It is a difficult format to construct images with. I try to construct an image in the frame rather than just take a wide view – an image that will not be just read from left to right. NB

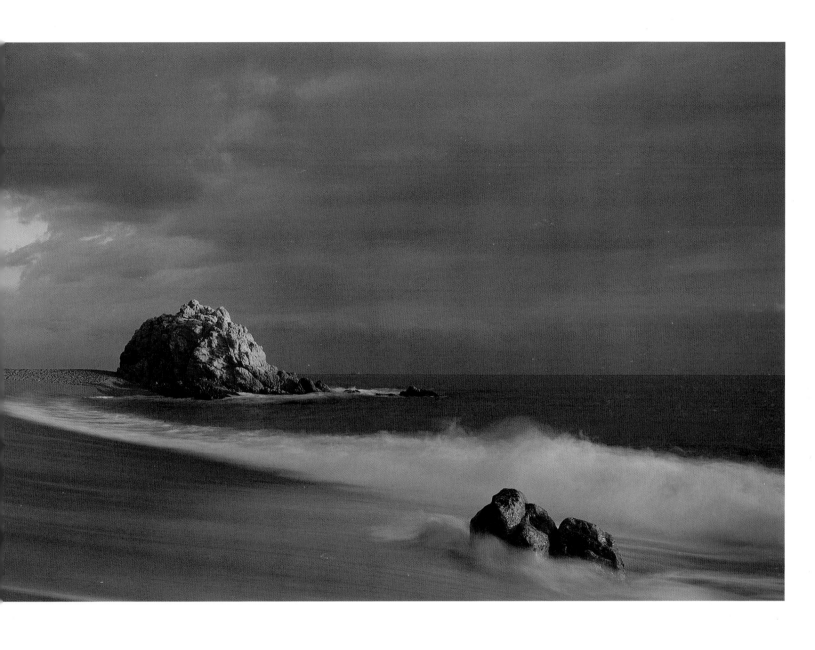

We learn how others see by studying their work and up to a point imitating it. If we are to develop our own vision and style we must look at ourselves and how we view the world. NB

Being a restless spirit, my vision of the landscape is one of a natural world that is in flux. I believe that very few landscapes are static and I try to convey this 'movement' through my images whether it is the physical movement in the landscape or the transient quality of light. NB

Scaleber Force
Nigel Baker [p143]

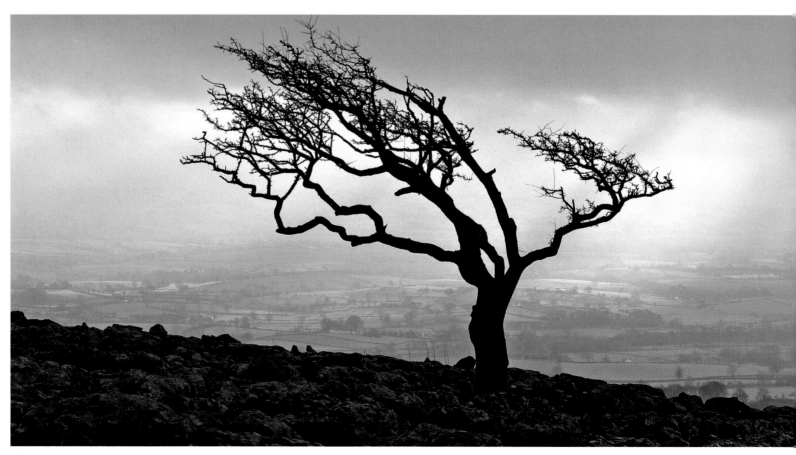

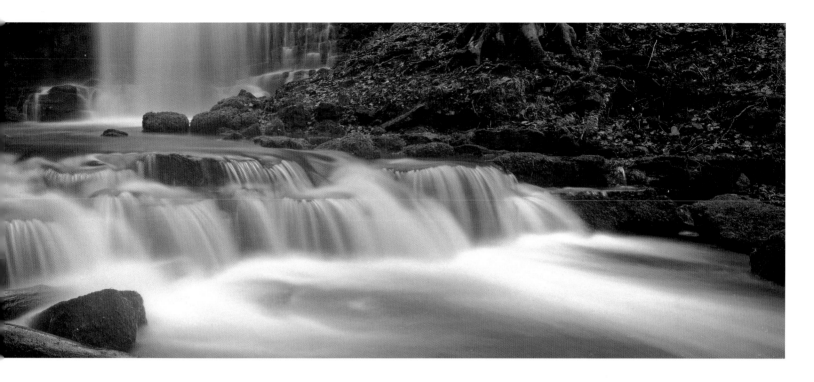

The major factor that limits creativity is a closed mind; when developing our personal style an open mind is essential. NB

Yorkshire tree
Nigel Baker [p143]

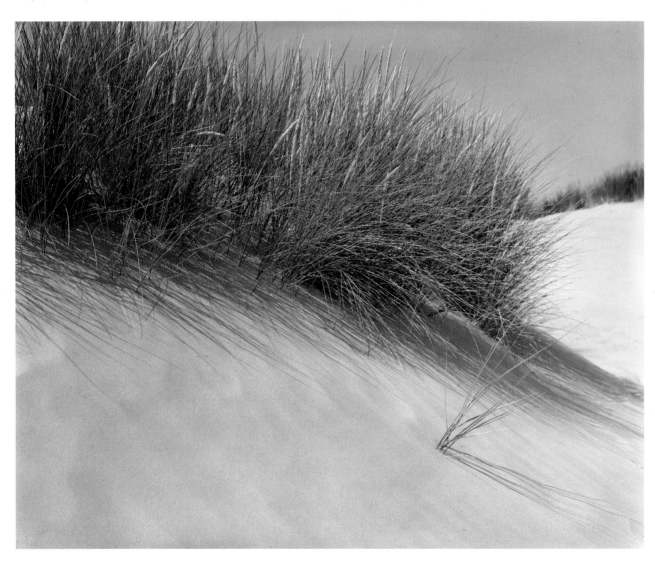

Dune and marram grasses
Paul Gallagher [p147]

Paul Gallagher

Vision to me is something that is not literal but borne out of the imagination. In a sense it is a translucent mask made up of dreams and thoughts overlaying reality. My vision is of a landscape that is fragile and beautiful, both in minutiae and vista, and constantly changing. My vision is in a perpetual state of flux and evolution as I learn more of how I wish to interpret the landscape and how I interact and respond to experiences and the images resulting from them. Perception of beauty changes in the eye of the beholder with time. PG

Pine plantation
Paul Gallagher [p147]

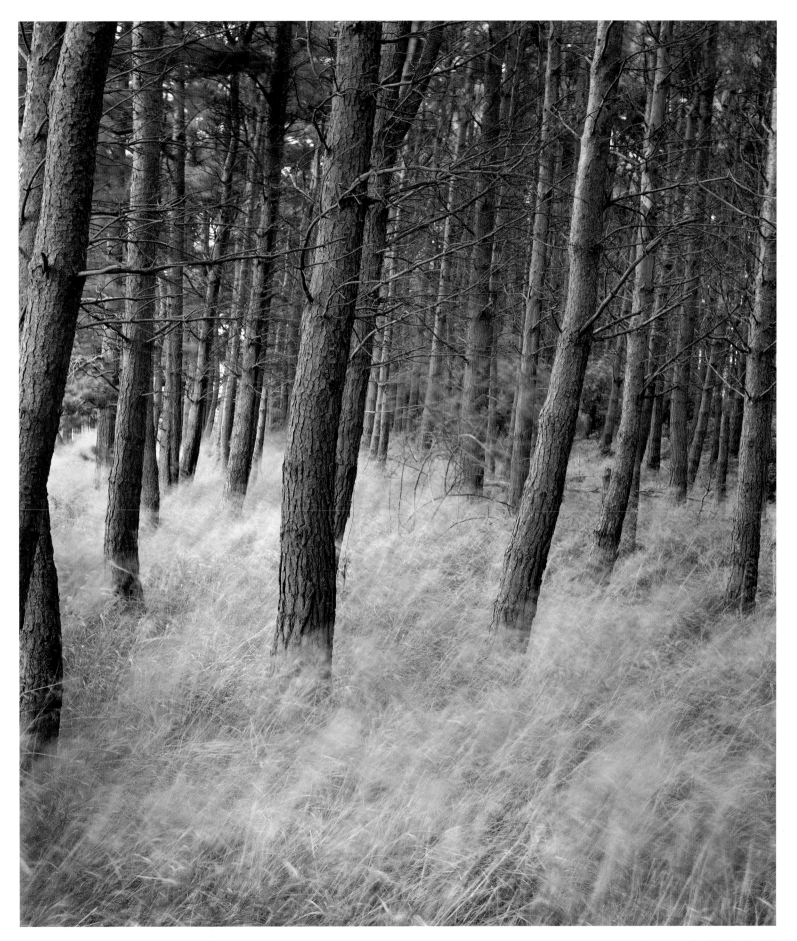

If style becomes your vision then you will become stylised. To be stylised is to conform to a style regardless of what you are intending to convey in an image. If style is allowed to evolve in parallel with vision then this will nurture creativity. PG

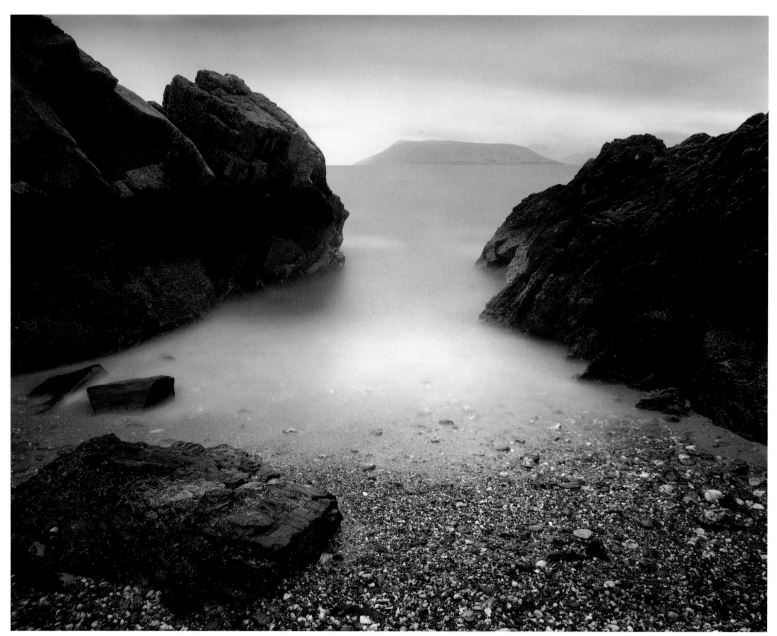

Skipness beach
Paul Gallagher [p147]

Buachaille Etive Mor and River Etive
Paul Gallagher [p147]

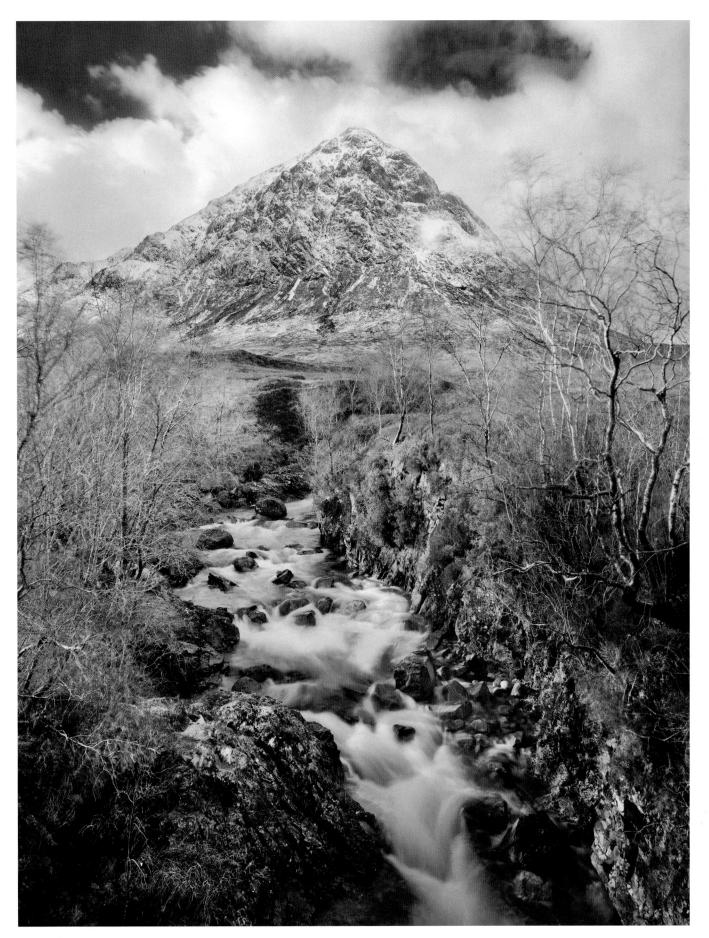

Adrian Hollister

Some would argue that 'visioning' skills cannot be learnt – you either have them or you don't. I would not entirely agree. As a typical analytical, left-brain thinker, I have surprised myself by developing artistic and creative skills in recent years! Over the past four years my ability to look at a landscape and envision an image has steadily improved, no doubt helped by studying the work of other photographers, attending photography courses, and a lot of experimentation. At last the right side of my brain is getting some use! AH

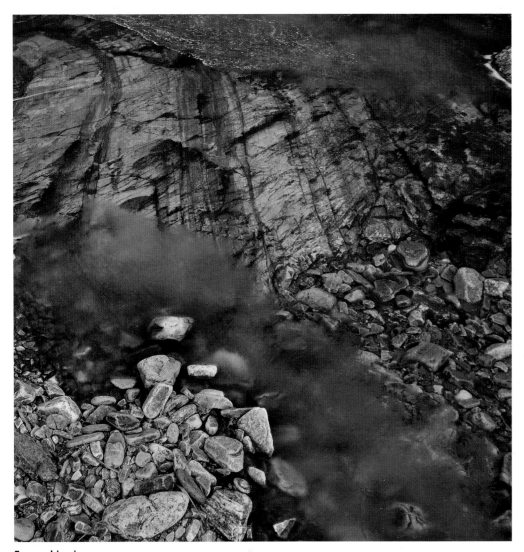

I am sure there will be many more changes and developments in my style. One benefit of being an amateur is that it allows me the space to evolve a style without the commercial pressures to become distinctive that I would be subject to if I were making a living from my photography. AH

Encroaching ice
Adrian Hollister [p148]

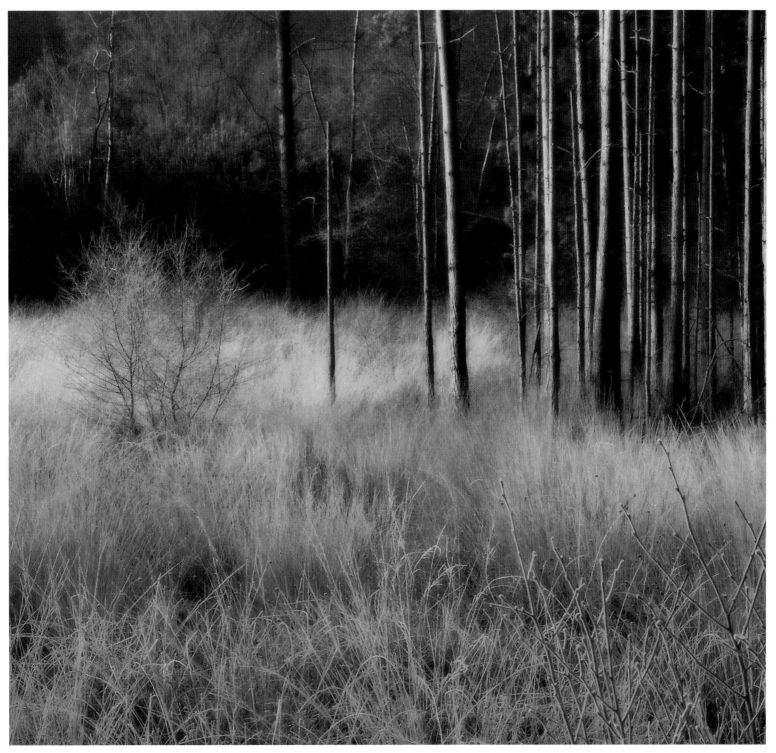

Forest at sunrise
Adrian Hollister [p148]

If style is a 'filter' to a photographer's vision, it follows that the artist's approach to 'visioning' the landscape will change as their style evolves. On the positive side, a particular style may enable the artist to 'envision' compositions not previously seen, and on the downside it may limit creativity by reducing the variety of opportunities the artist can perceive within the landscape. AH

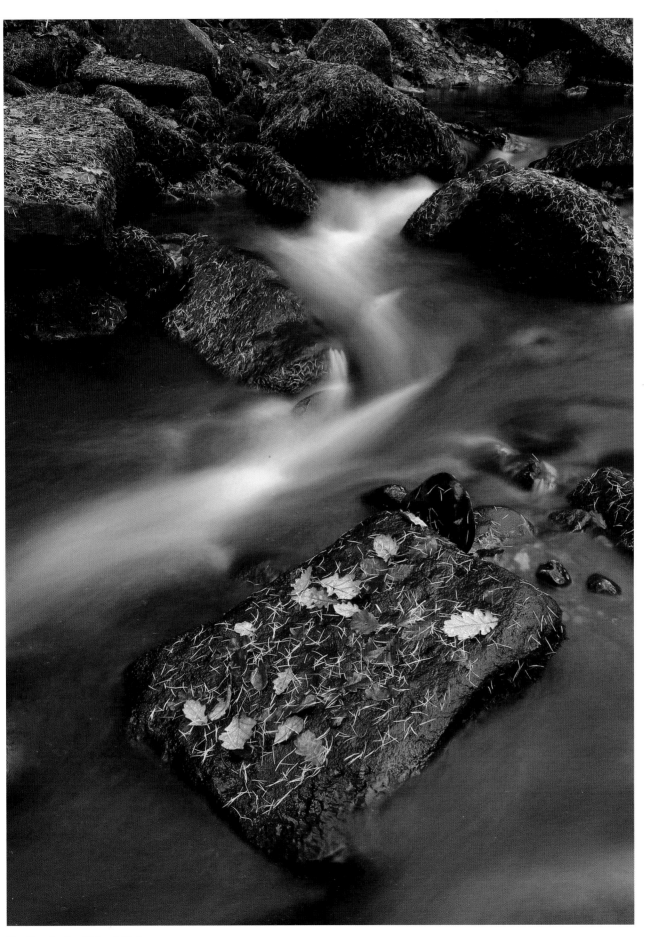

Autumn glory
James Michael Cox [p148]

EE: Melanie Foster asks 'How do you strike the balance between having a distinctive style of your own and not getting stuck in a rut?'

DW: *I think part of the trick might be not to consciously strive for a distinctive style. Style should arise from your unique approach to your subjects, from the way that you see and feel about the world. As your journey through photography progresses you will naturally see new subjects in a new light and so your vision and style will evolve.*

CW: *This has been the conundrum that has plagued me for the last ten years of my work. I feel that I am on my own in this respect and that it does not trouble others in the way that it does me. I continue to respond in the way that I always have to certain arrangements within the landscape and am sure that this will always be the case. However, I do feel that following a formula' could sound the death knell for the continuation of fresh and genuine exploration of self. It seems to me that if every image made is simply another 'version' of its predecessor then self-development will be stifled. For better or worse, therefore, I have thoroughly enjoyed the occasional challenge and foray (often stumbling) into other, uncharted, photographic waters.*

JC: *Great question! Perhaps the best answer is to not really know what your style is! Where I am now, I usually have an idea that I am aspiring to realise and the light is usually such that I very rarely succeed, so the final result is imperfect. It is hard to get stuck in a rut when you haven't yet managed to lift your work up to the level of the 'rut' you might get stuck in!*

James Michael Cox

Vision is the ability to recognise and capture all the components of an image that build the backbone of the composition; it is the ability to imagine the landscape as a finished image. My hope is that I can arrive at a deeper insight into the land and the way the light affects its moods. The aim is to develop my work from a visually correct image to one that has a link to the viewer on more than one level. I have almost always used wide-angle lenses and I have rarely used a lens above 35mm. However, my work is evolving and I'm beginning to occasionally use a short telephoto lens. JMC

Chris Andrews

It is difficult to answer the question 'What is vision?' because it is a fairly abstract concept. After much thought, I decided that the best answer was actually based on another question. So, for me, vision is being able to answer the question 'Where is the picture?' when confronted with a scene. On occasions the answer will be obvious – it will be sitting there in front of you, just begging to be captured. On other occasions the answer can be elusive, and you may not even find 'the picture' before it is time to move on. CA

These are some of the key lessons I've learned on the way:

'Get out more, take less.' These wise words come from Joe Cornish. Using my Iceland trips as examples, in 2001 I rattled off around 20 films in two weeks, out of which I got a dozen or so pictures I was happy with. In 2006 I got through just 7 films (plus another 50 shots on digital), with most images bracketed ½ a stop either way, so the number of different images was reduced by at least a quarter. Now that I'm working on 5x4, I do well to capture more than three images a day, but the overall success rate is much higher. Of the 20 or so images taken on my first 5x4 trip to Vermont in 2006, well over half were real stunners.

'Analyse what you take and work out why it does (or doesn't) work.' Wise words, from David Ward this time. There is an awful lot to be learned from just looking at your images and comparing them to your recollection of the scene at the time. Does it remind you of where you were and what you felt at the time? Does it represent your vision at the time? I think it is equally important to understand what 'works' and what doesn't. This discipline also should allow you to apply the same process when out in the field to assess the image before you press the shutter. CA

So how has my vision developed? In many ways it hasn't changed all that much, but I have got much better at recording it on film. A combination of improvements in confidence, dedication, concentration, technique and equipment mean I now capture my vision more often than not. I have also been greatly influenced by the interaction with other photographers. CA

Bliss Pond
Chris Andrews [p148]

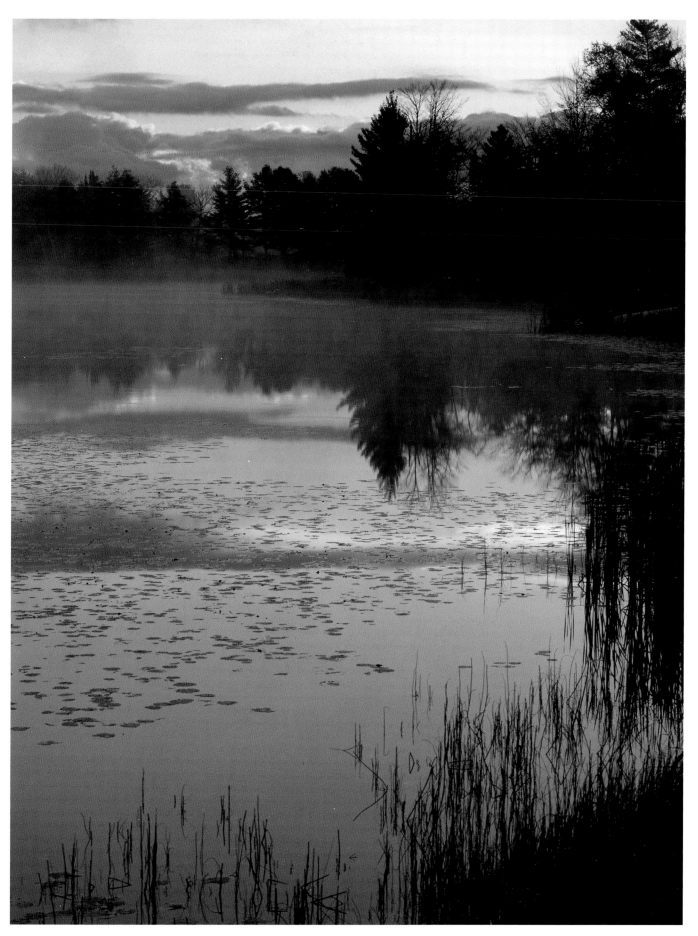

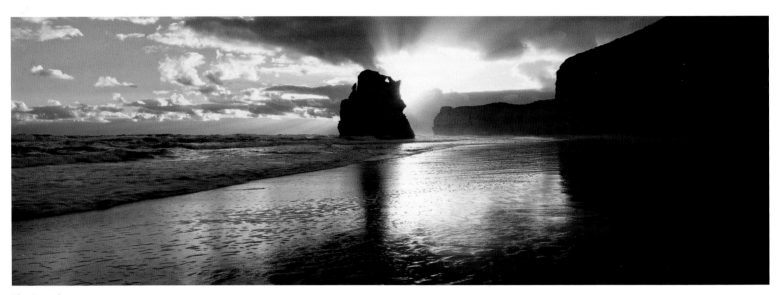

The Apostle
Michael James Brown [p148]

Michael James Brown

For me, vision is about understanding the conversion of a scene from what the eye sees to how it is portrayed in a resulting photograph. Rare light on a beautiful landscape is not only a visual experience, it is also an emotional experience. For me, vision is conceptualising the unseen final photograph and not only capturing light – but also capturing and conveying the emotion I felt when I was taking the photograph. MJB

At the point of capture, the photographer benefits from the entire scene, not only the light in the landscape but the scene's scale and depth. Only a small portion of a landscape can be included in the viewfinder. My vision of a final image helps me to ensure that the exclusion of the periphery of a scene does not prevent me from conveying what I saw and felt when I was there. MJB

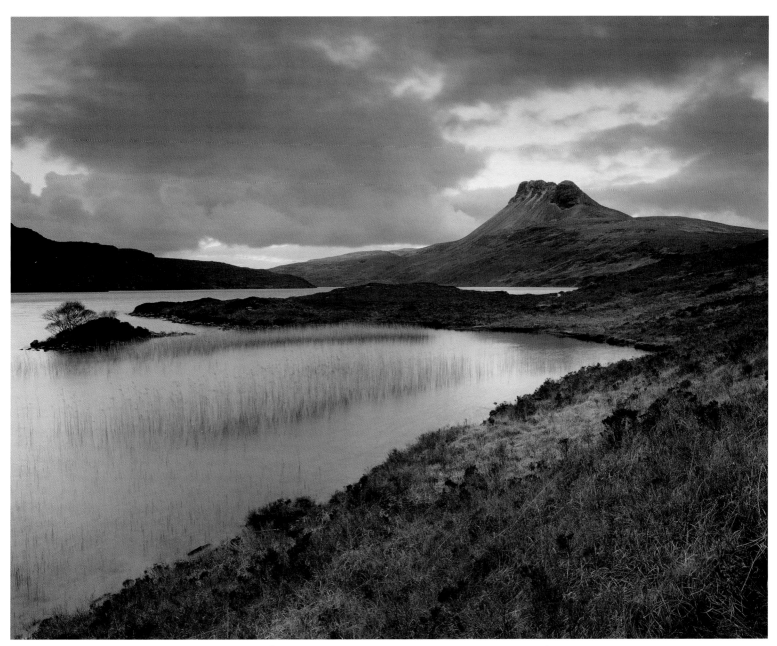

Reeds on Loch Lurgainn
Ross Brown [p148]

Ross Brown

My photography has been a step-by-step journey and during the last couple of years I have been principally focusing on different photographic techniques. Only now, as these techniques slowly slot into place, have I started to look at vision and style. This is an exciting challenge. It leads me to question why I take photographs, what I am hoping to do with the images and how I can develop a photographic style and a unique body of work. RB

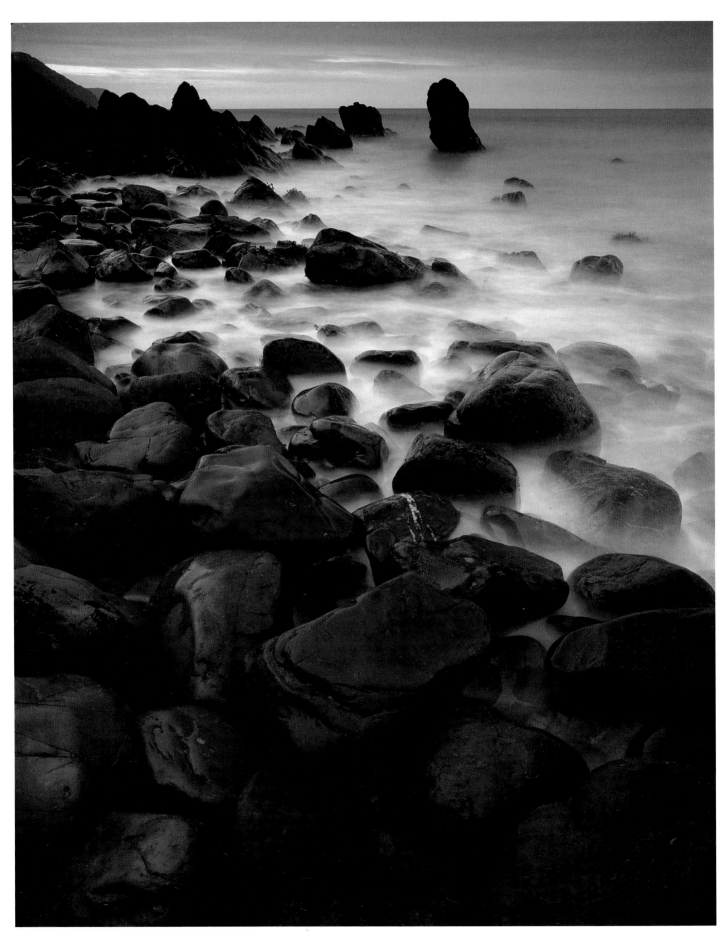

EE: Would you consider switching to digital?

DW: *It's hard to imagine that I would ever get the emotional response from seeing an image on a monitor that I do from seeing a 5X4 transparency on a lightbox. But putting this aside, the main reason that I won't be switching any time soon is simply economic – I can buy several years' worth of film for the price of a digital back.*

JC: *Quite possibly. Unfortunately, as you probably know, there is no product/work flow that really is directly comparable to working with large-format film just yet.*

CW: *Not yet. I herald the arrival of digital and think it is a wonderful and creative medium. But there is still a great deal to be said for the pleasure of laying down a transparency on a daylight-balanced lightbox coupled with the very familiar stoop to see the image through a high quality loupe. Despite some fine digital projectors, the projected transparency is still hard to beat.*

Sean Lewis

Vision is seeing a meaningful connection between reality and what you see in your mind. My vision is to compose, interpret and encapsulate nature's art in my own eyes. This vision is based on a genuine and life-long love of nature and wild places, from exploring rock pools and running off in the hills of Minorca as a child to the continual longing to get off the beaten track. SL

I think my style, like anyone else's, improves with practice as well as with looking at the work of other artists and photographers. I also think my style is becoming more profound, as I am learning to look at a subject in a more constructed and composed way. I'm also learning how a subject is lit as well as the mood it puts me in. I think style can only enhance creativity. An image without someone's personal style is an image without thought. SL

Porlock Bay
Sean Lewis [p148]

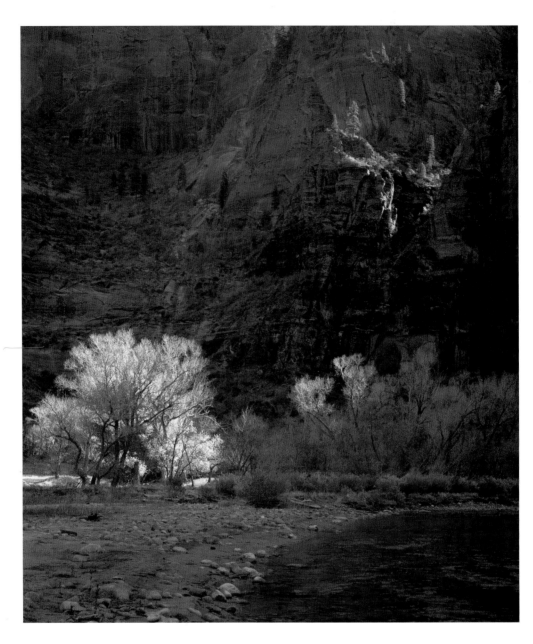

Zion lIght
Julian Barkway [p148]

Julian Barkway

I would describe my vision as 'emerging'. I am in the process of learning, analysing and forging a direction. In that sense it is also 'evolving'. Since moving up to large-format equipment, I have found that it is becoming easier to make images that are less about learning technique and more about expressing the way I see the world. JB

I am not sure I am at the stage where my individual style has emerged, but in selecting images for possible inclusion in this book, I have noticed a preference for certain subjects, certain compositional devices and a restricted colour palette. This is, however, not a result of conscious choice. JB

May Beck
Julian Barkway [p148]

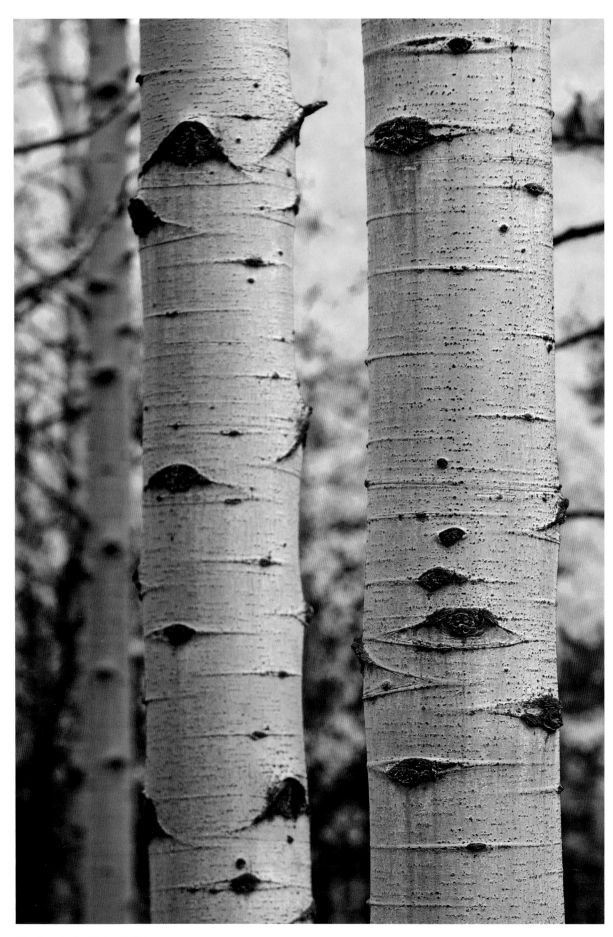

In my opinion, style is like a signature, a collection of elements that allows you to distinguish the work of one photographer from that of another. JK

Aspens
Janneke Kroes [p149]

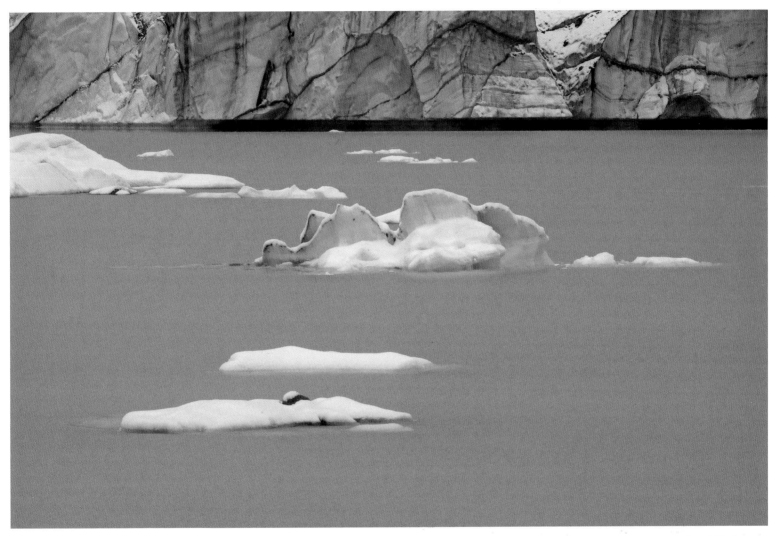

Angel Glacier
Janneke Kroes [p149]

Janneke Kroes

To me, having vision means being able to incorporate a 'message' into your image that will have a certain impact on the viewer. However, when I make my images I'm still too preoccupied with getting the basics – composition, exposure, etc – right rather than thinking about what impact the picture may have. To be honest, I don't know if I've got as far as developing my own style yet. If I have, I couldn't describe it. If somebody else could describe it to me, great! JK

Paul Marsch

I think of photographic vision as having three components, or layers. First, what is my overall photographic vision? Second, what is my vision for my current or next photographic project? Third, what is my vision for the next image I will make? To me, vision encapsulates style, subject, tone, colour and composition, etc. Importantly though, vision goes beyond these technical components to include the key elements of communication and intent; what is it that I want to convey with a particular photograph and how am I going to achieve it? Vision is easy to define on the page, but elusive to achieve in practice. PM

My main ambition when it comes to my photographic vision is to have one! That may sound a touch flippant, but I think of vision as something that is specific to a particular time and, at best, evolving. PM

Allt a Choire Ghreadaidh
Paul Marsch [p149]

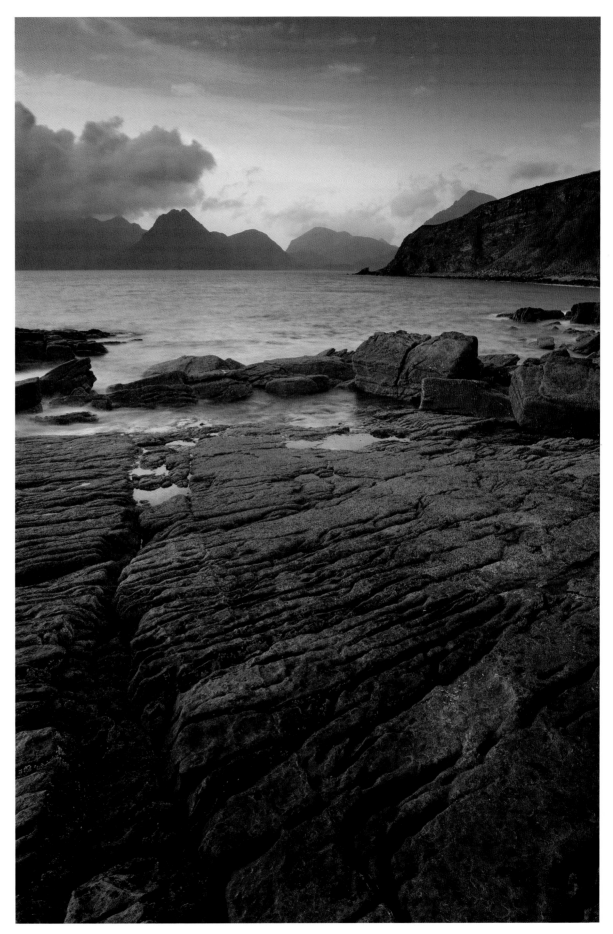

Elgol evening
Paul Marsch [p149]

Cloud and tree
Richard Holroyd [p149]

Richard Holroyd

For me, vision is a result of what you notice. Vision begins with what you are drawn towards and the feeling that is generated inside. It's that 'wow' moment when all you want to do is simply look. Different people notice and are drawn towards very different things. I am drawn towards the way the elements of a place fit together – the shapes, the colour and texture. I have an urge to create a picture that captures the 'wow' feeling – to capture what I notice. RH

Is it possible that style can inhibit creativity? If I slavishly use the same camera and believe that my last image is my best, then I think it does. That old saying, 'If the only tool you have is a hammer, then everything looks like a nail' also applies to the way I approach photography. The saviour of creativity will be vision; I will continue to look more closely, to notice more. RH

What can we learn from looking at the work of other photographers? I learn that there is yet another way of seeing the world. Copying is pointless. Being inspired to find your own concrete slipway, clump of cypress, round rock or two pebbles is good. However, it's better still to be inspired to use other photographers' vision and style as a basis for trying something new and being surprised by what you have achieved. RH

Beach balls
Richard Holroyd [p149]

Knockanes and Lough Gealain
Hazel Coffey [p149]

Hazel Coffey

Maybe one should start by considering what a photograph actually is.

A photograph is a communicative action, and in those terms requires that one's vision is intelligible and accessible to a range of other people. Authenticity and lucidity of intent are key. One of the maxims of the theory of communicative action states, 'be perspicuous'; that is, lucid, intelligible, and clear in intent. So, no contrivances. I want a picture of mine to look, as Lady Bracknell said about Cecily's hair, 'Almost as Nature might have left it.' HC

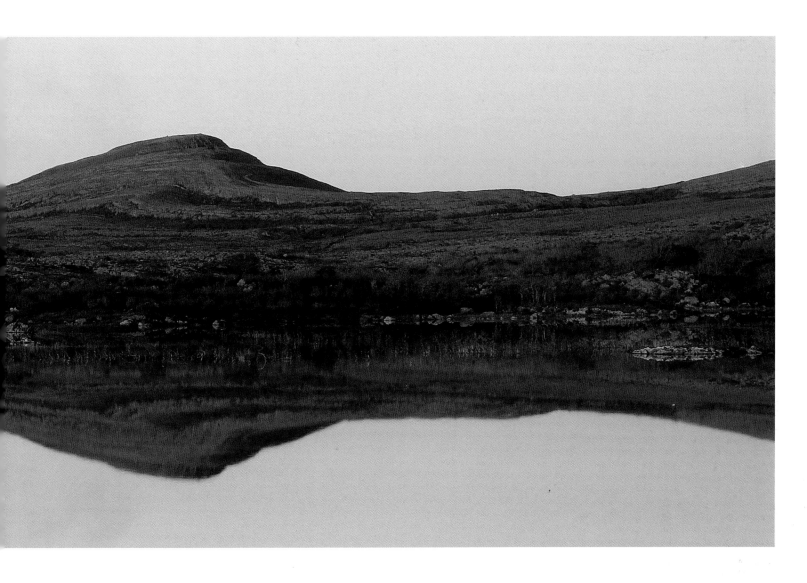

In the Middle Ages people believed that human vision worked like this: the eyes emitted beams of light which threw illumination on the items seen, rendering them visible. All image-making could be considered as occurring in an analogous manner. The maker of the image is the source of light, and the filter through which a scene or landscape passes in order to be represented in accordance with that person's individual vision. It is stamped with the individual's manner of viewing the world, in accordance with temperament, culture, models, and heart! So that is perhaps what photographic vision consists of. An authentic image is an expression of what the heart sees. HC

I imagine that my vision is grounded in the fact that so many things that I see 'rejoice my eye', to use an antiquated phrase. They ought to be seen; they merit regard; and their influence is beneficial. I believe there is a moral dimension to it all. Rilke says that the activity of vision, of paying due attention to the external constituents of the world, is enjoined on us as a duty: we are commissioned to see, and if we do not, we are losers thereby. HC

Michéla Griffiths

*My style is evolving. Through experience and reading, I feel my way of doing
things is progressing, and kind comments from others suggest they agree. I've
found that getting to know an area helps greatly, as I can learn from what
did and didn't work on a previous visit. This has been particularly helpful in
simplifying composition – perhaps selecting a less cluttered foreground, or
stronger lead-in lines, or returning with an understanding of what will work
under particular lighting conditions.* MG

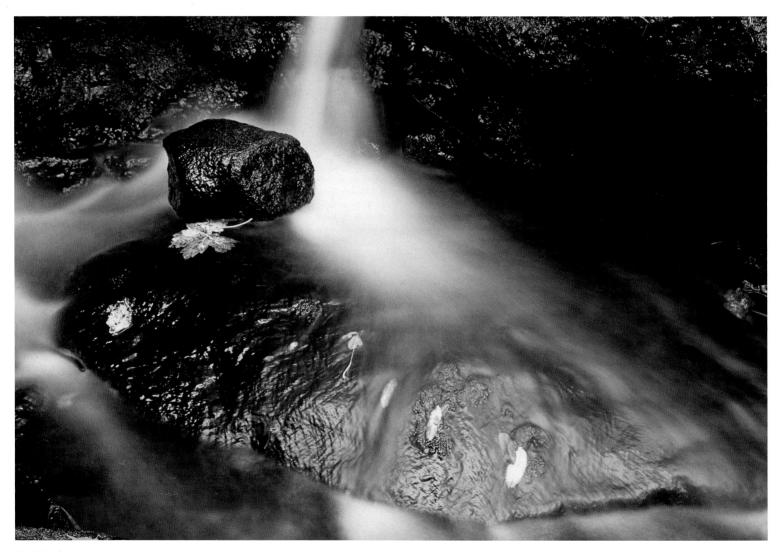

Hay Wood
Michéla Griffiths [p149]

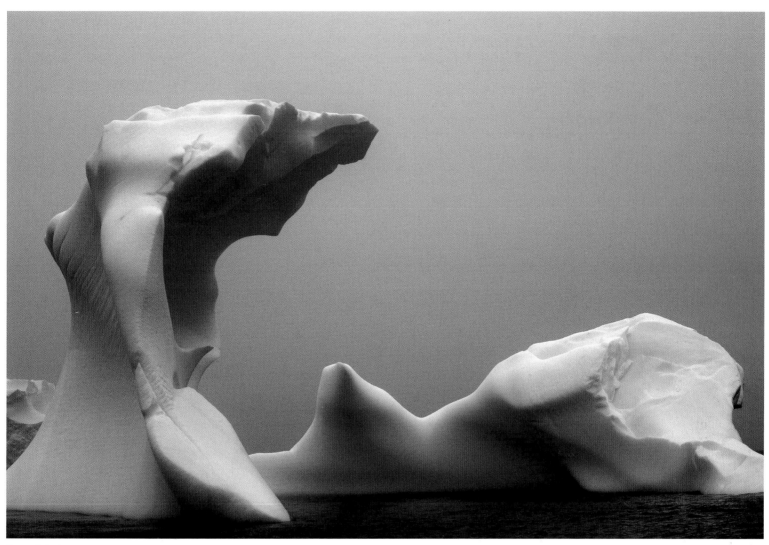

Antartic Iceberg
Pat Douglass [p149]

Pat Douglass

Vision has to inspire, to raise the subject above the ordinary. To go beyond the everyday, there has to be an emotional connection, a power that connects me to my subject and to the potential image. The challenge is to record that connection, creating a power within the image that plugs in to a deeper emotion, both in the photographer and in the viewer. PD

EE: After many years in photography, whose comments about your vision or style have been most helpful – why, and what were they?

JC: *I am sorry to say that in spite of the great feedback I have had from friends, fellow workers and clients over the years, none of it has really been commentary on my vision or style. Some of the feedback has been embarrassingly generous (the British Ansel Adams etc), but you still couldn't call it critical/analytical, though Charlie described his reactions to four of my pictures in* Working the Light. *You could say, I am still seeking approval!*

CW: *I do have comments made to me about my work and, as with many of us, newspaper and magazine articles have been published about it. Often, when reading a critique of my photography, I feel slightly detached, as if the author might be talking about another person. There is no doubt that a review of one's work that is complementary is particularly rewarding when the source is well qualified to offer it.*

DW: *A tutor at college once told me that the problem with a body of work that I'd made was that I obviously didn't have an opinion about what I was photographing. This was fundamental to my understanding of how to make good images – you've got to have an opinion about your subject. It can be positive or negative, but you've got to care!*

Frans R. van Wilgen

Vision defines what is significant to the picture and results in a shortlist of 'matters' I wish to convey through the image. Alternatively, vision could be interpreted as a dream of how or what my photography should be or could become in the future. If one has formulated this dream, it is easier to think about a plan, a strategy, to make the dream come true. Within photography there is room for both definitions; I would think of the first to be the short-term plan and the second to be the long-term strategy. Presumably, we need to develop them both. FRvW

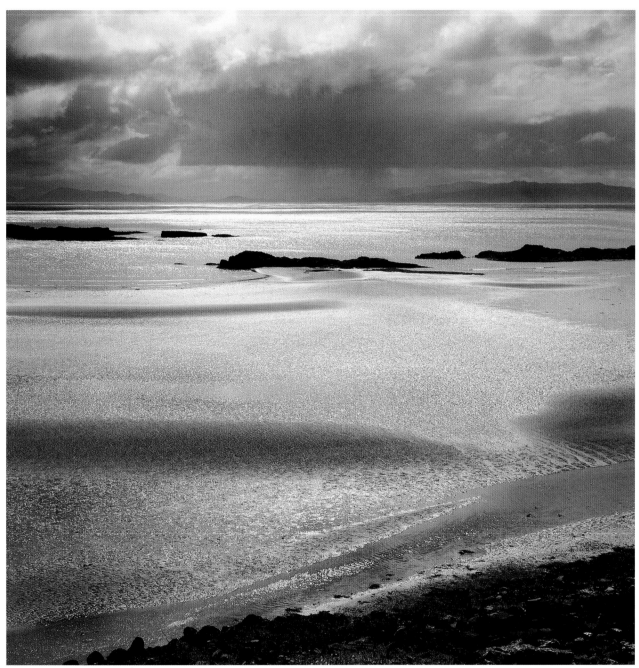

Kildonan Bay
Frans R. van Wilgen [150]

My vision is evolving. I notice an increasing urge to be engaged in it, thinking 'if only I could do this more frequently' and wanting to discuss my own and others' images. I struggle with the process of how and what to say or address and spend more time reading, visiting exhibitions and taking part in group learning experiences. It's all part of the growing process, I hope. It is probably too early for me to say whether my style is evolving. FRvW

VISION DETERMINES STYLE

CHARLIE WAITE

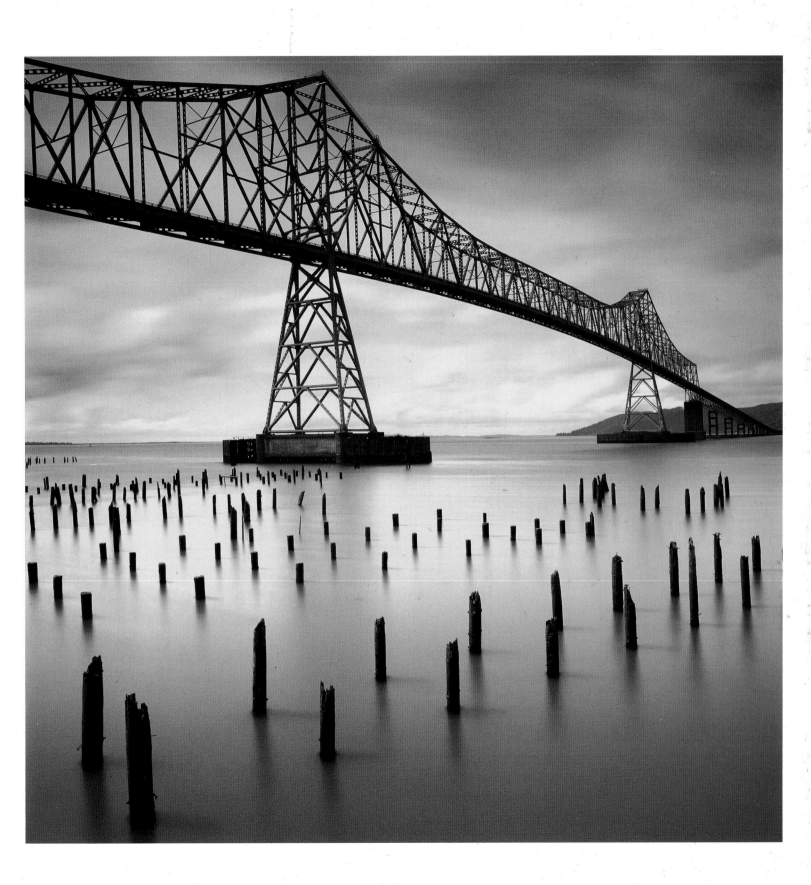

Our vision should dictate our style and the entire image-making process. If the latter does not reflect the former then our work will seem hollow and without meaning. There will be a dislocation between intention, execution and outcome; the image will be found wanting. CW

Charlie Waite

PARADOXICALLY PERHAPS, the concept of photographic vision is so intangible and esoteric that the only language that can be used to define it is the medium of photography itself. Describing an image in intellectual terms is the business of a gallery curator or an art reviewer, but to the creator of the work, this language of explanation is unknown and never spoken and perhaps barely understood; the image is the thing.

Personal experience is perhaps the only possible way in which to try and delve into the various sources from which the urge to create springs; to attempt to tie that impulse down with definitions and explanations seems a futile and inconclusive task. Surely it is subjective, intuitive feeling and personal interpretation manifesting itself in tangible art that is the very stuff of inner vision.

DEFINING STYLE is perhaps more straightforward as style is subject to fluctuations of influence and changing taste. Style can reflect our own evolution as photographers but can also change in response to external forces that could undermine firmly held convictions, leading to a loss of confidence and total abandonment of previous photographic styles.

Instinctive and perhaps formulaic placement of elements in the name of aesthetics, once held dear, may suddenly be seen as crass and too safe. Style, always evolving over time, will not be embedded in our consciousness as vision is; our image-making style is a lightweight relation to the profundity of our deeply held personal vision.

St Girons, Pyrenees
All the ingredients were on offer: hard, oblique light; boiling, disintegrating cumulus cloud; two peaks at either side and one, broader, peak beyond with snow as a bonus. And yet, this image just falls short of my expectations. What were my expectations? More atmosphere and a greater sense of depth which is not conveyed to me 'sufficiently' in this image.

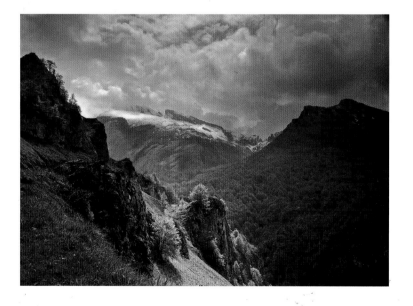

Cows, Islay
I have always been drawn to silver within a landscape image and it is often water that provides it. There is a humour and a serenity that I thoroughly enjoy in this image and the cows in this incongruous setting provide both a slightly absurd element and a spiritual one. Due to a vague matching of shapes, there is a suggestion that the base of the cloud was once attached to the back edge of the grass, giving a feeling that a parting of the sky and land has taken place to reveal the cows paddling in a silvery, milky sea. It is probably my romanticising things, but it is hard not to feel that they are celestial cows.

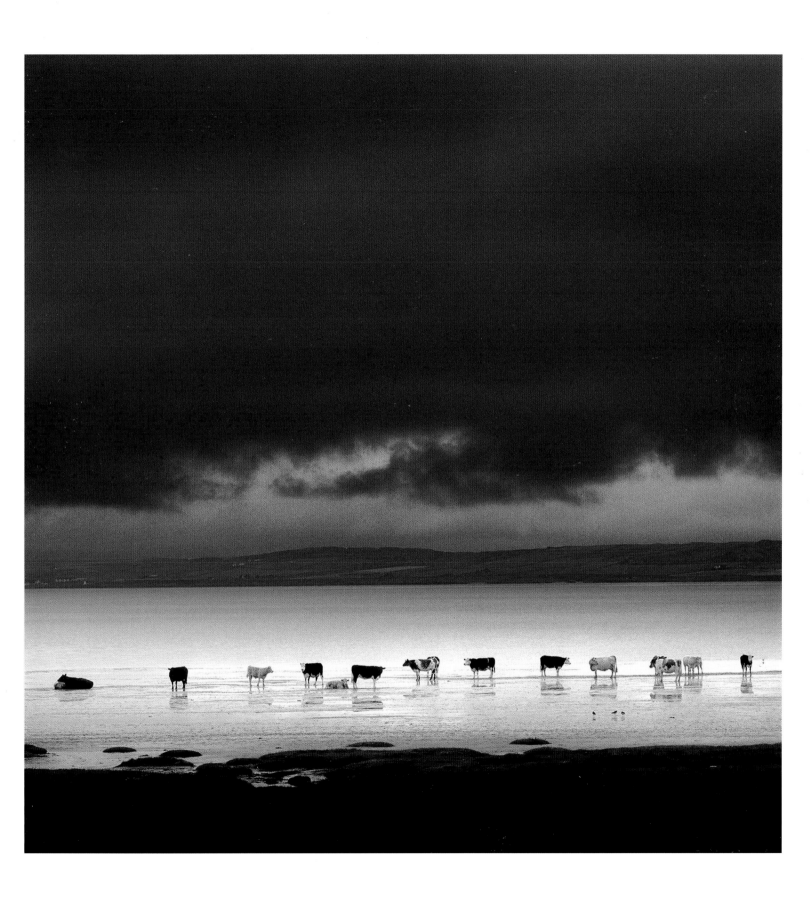

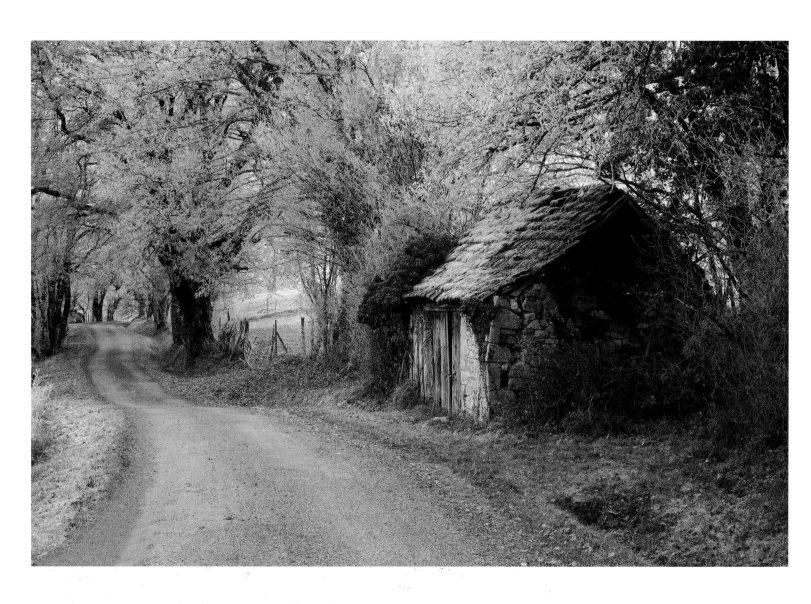

Autoire, The Lot

It is no secret that I have a great fondness for sheds and it is no secret that I am not alone in this. I spent Christmas 2006 in the department of the Lot in France and found this shed apparently waiting for me; it seemed fitting that I should find it on Christmas Day. The phenomenon of a hoar frost is exquisitely beautiful and gave an unexpected, fairy-tale, sugary background to the setting. The occasional splatters of orange, especially on the mossy roof, give me great pleasure. The way that the overhanging branches appear to be protecting the shed is touching to me. There is no denying that this image is romantic and that is exactly what impelled me to make it.

THE COMPOSER WHO is struggling to find a new melody but finding that no inspiration comes may either return to the safety of replication with minor variations or attempt to redefine himself by quite literally throwing away the score in some great flourish of revelation and embarking on an entirely new approach. The latter step can sometimes be a cathartic and cleansing experience.

This state of affairs is perhaps the same with any artistic endeavour. Repetition of style can be seen, on the one hand, as the photographers' signature which is perhaps admired and mimicked by others, or, on the other, as a talent or even a gift that should not be modified and should remain sacred. The voice you have is the only voice you need. The photographer's need for inspiration and variety should be adequately served by the huge choice of subject matter and lighting conditions that the landscape has to offer. Perhaps these are enough to keep him fresh and stimulated with each new subject presenting a new set of challenges.

SO FOR ME the twin concepts of vision and style are essentially very different in nature. I certainly do not feel that my own 'photographic vision' is more valid than anyone else's but the creative pleasure and fulfilment that has come from my years of making images is something that has shaped me as a person and must be a key part of who I am.

Looking at things in a slightly broader fashion, I have always sensed a form of allegiance to the landscape and when photographing I am aware of feeling truly at home; secure and safe. I am aware of my camera as the catalyst which allows me to react in some way with some of the great fundamentals of existence; the landscape clearly being one of them. Like a gardener or farmer who watches over the ground and sees the soil deliver up new life; through the camera I become the recipient of a degree of understanding; through it, I seem to be able to find answers to things. There is no complexity to this simple exchange.

However, for some, the search for the perfect image becomes a defining factor in their life. I am clear about the perfect image always being elusive and long may that continue. Might it be the pursuit of perfection that drives us onward?

Limoges, France
It could be that this image simply contains too many conflicting elements. There is a sense of order to be found in the back third of the image with the regimented line of trees, but a conflict seems to arise from the frozen grasses in the foreground which do not 'shake hands' with the trees, in my view. There is a definite confusion in this image that I did not think would be apparent when I made it. I guess I felt that the binding catalyst of the hoar frost would make the image work. If the temperature were to have risen, I wonder if the image would have remained to have been found another time?

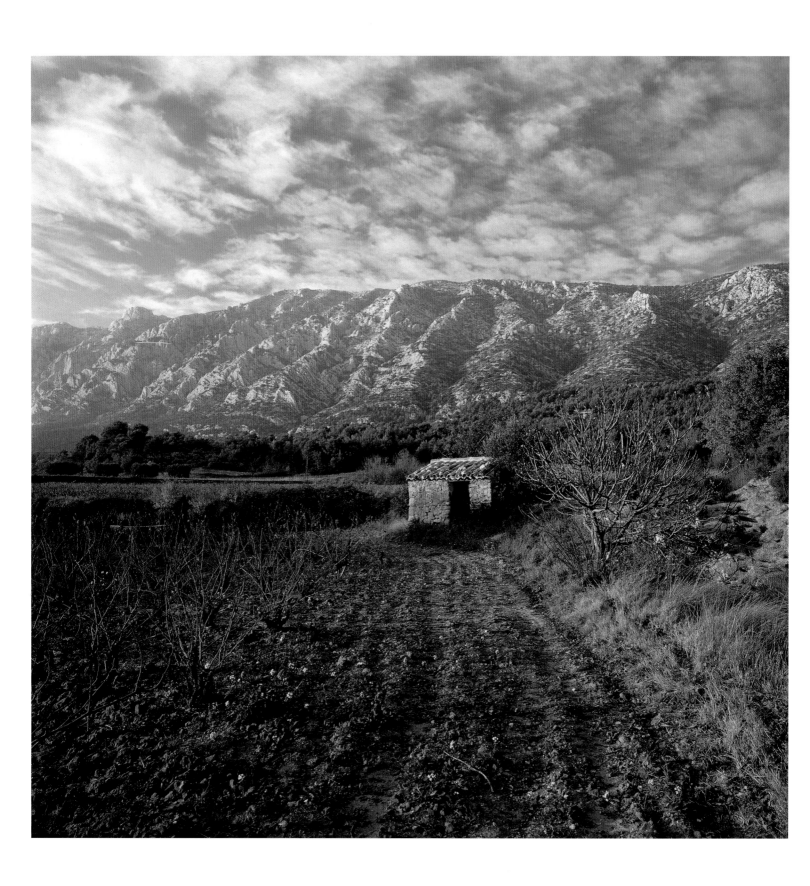

I am aware of the need to immerse myself in my work and invest as much of myself in the making of the image as I can, but this absorption is part of any creative effort. I am intrigued by why an image might disappoint; what conflicting constituent parts have caused the failure? CW

THERE CAN BE NO DOUBT that without vision of some sort or other, the landscape photographer (or for that matter any creative individual) will produce work that falls short of the objectives and the aspirations of its creator, leading to disillusionment and disappointment. The antithesis of this is the supreme joy and reward that can come from making an image that conveys both something of oneself while also transporting others to a particular place and enabling them to share the sensations that you experienced where the image was made. I commend landscape photography to one and all.

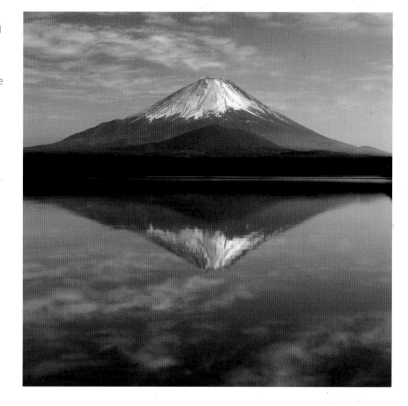

Mount Fuji

I had been privileged to go to Tokyo for an exhibition and a few days before I was to leave, I asked if I could go and see Mount Fuji. The rain in the morning worried me but my guide said I should remember that where we were going the rain would fall as snow on the high ground. The famous cloak of snow over the summit was perfect and it seemed that all was well. Sadly, the image fails because of the aggressive, hard, horizontal wedge of deep black shadow that fiercely bisects the soft, muted colour of the surroundings. This conflict upsets me and despite my pleasure with the remainder of the image, I am left dissatisfied.

Mont Sainte Victoire

While living in the beautiful city of Aix en Provence, Cezanne was frequently drawn to paint the long, whale-backed mountain of Monte Sainte Victoire; I am intrigued as to why he was unable to leave it alone. This was one of the first images I made in Provence and I have always had a great affection for it. All is bathed in a warm amber glow and the relationship between the speckled altocumulus, the deep, corrugated clefts in the mountain and the shallow furrows of the red earth seem to blend happily with each other. A part of me might care to live in the shed. Out of curiosity, I have passed by the mountain again and been unable to find this place; I shall probably not look anymore.

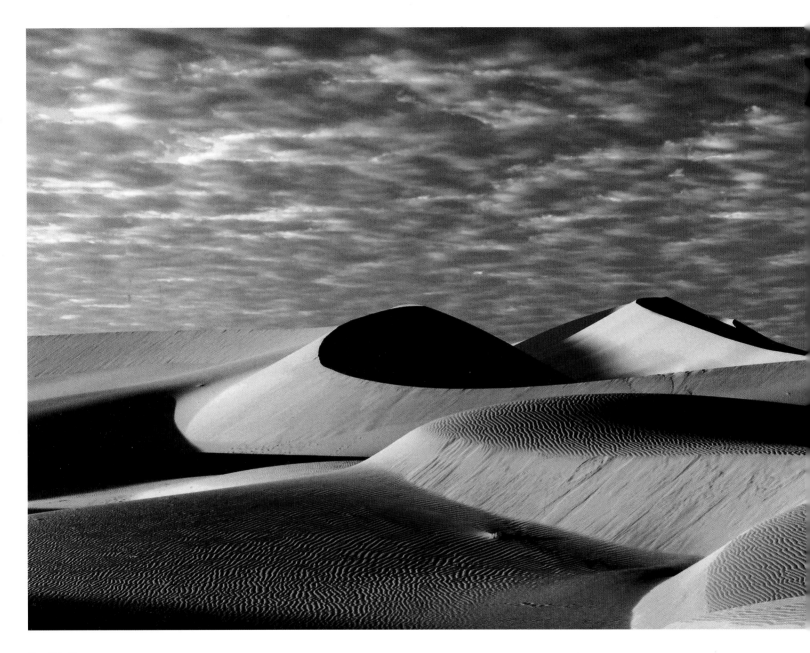

Namibia Dunes

This is one of the images that I have grown more and more fond of as time goes by. The two different types of shadows hold great appeal to me; the edge of the ones at the back of the image are razor sharp while those in the foreground retreat and gently give way to the encroaching light of sunrise. The ripples, barely a centimeter high, help to delineate that gradation. The mottled sky canopy above sometimes appears to me to be the 'wrong' sky and I do wonder if an unobtrusive, pure, single-tone sky might have set the dunes off more emphatically.

Might it be that defining one's own style is as hard as any other form of introspection? It is impossible, for example, to perceive oneself in the way that others may see you; by the same token one's style might be too opaque to oneself for us to characterise it. I am unable to say who has best described my style. Perhaps, if an individual is good enough to acquire my work then that is sufficient. It is tremendously encouraging when this happens and perhaps can be seen as indicative that this small exchange has had some meaning. CW

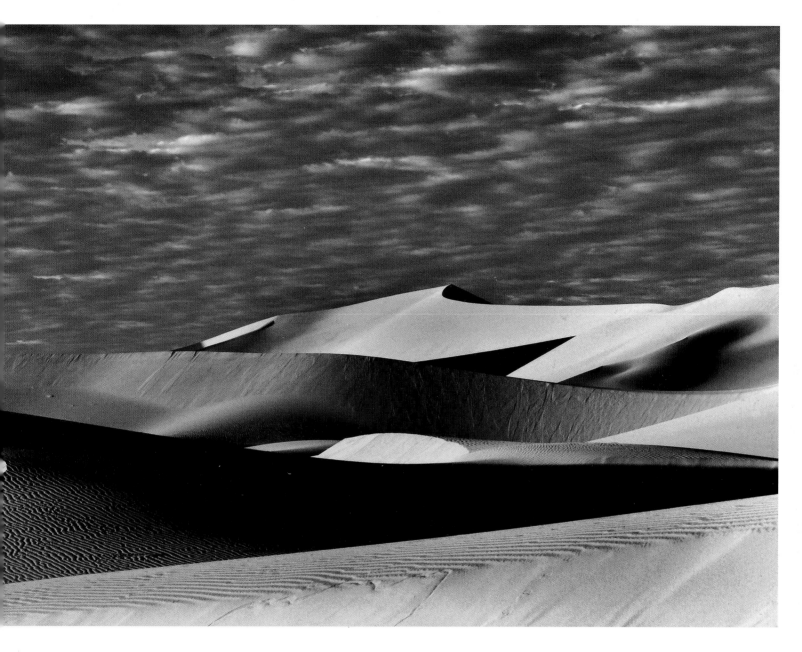

Trinidad and Tobago

This image was supposed to have told a story of primitive reed boat building but it falls well short of fulfilling that brief. It was hoped that, ideally, the arced shapes of the hulls would have appeared to be similar which they patently are not; I knew this at the time but disregarded it as something that would simply not matter. It does – to me. I like the choice of black and white and feel that the texture of the reed bindings is better conveyed in monochrome.

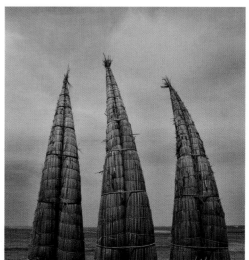

GALLERY FORUM – 2

Photographers discuss vision & style

What does 'vision' mean to me? Well, that is the sort of question that I always promised I would never try to answer, and the answer to which you could probably find in dozens of painful biography sections of a certain sort of photographer's web site. You know the kind – 'I humbly aim to try to capture the awesome bounteous beauty of Mother Nature,' and so on. Well, that doesn't really seem to be vision, just bad prose. However, in photographic terms I would say that vision is how you see the world (figuratively, not literally) – your photographic manifesto, perhaps? Your style is how you then implement that vision. Andrew Barnes

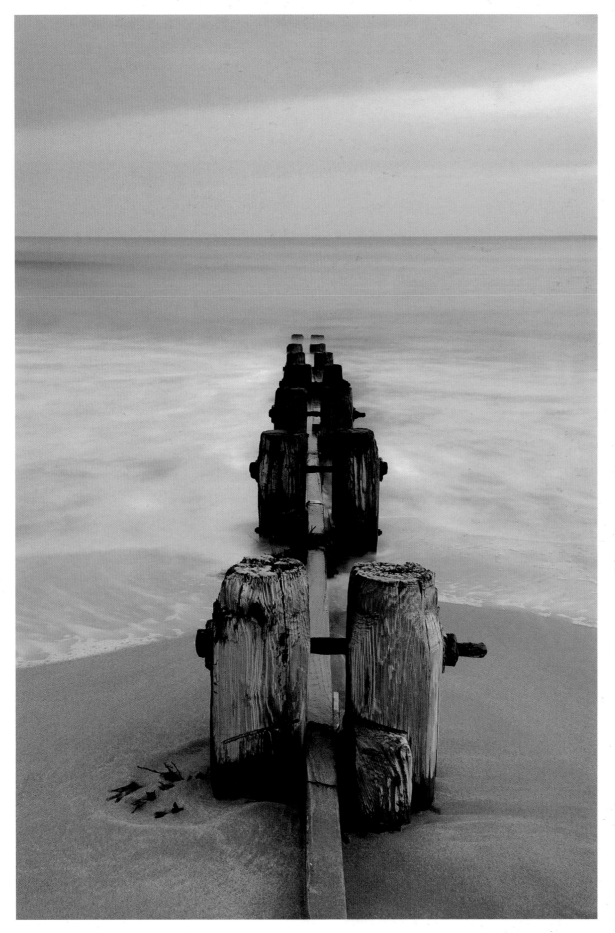

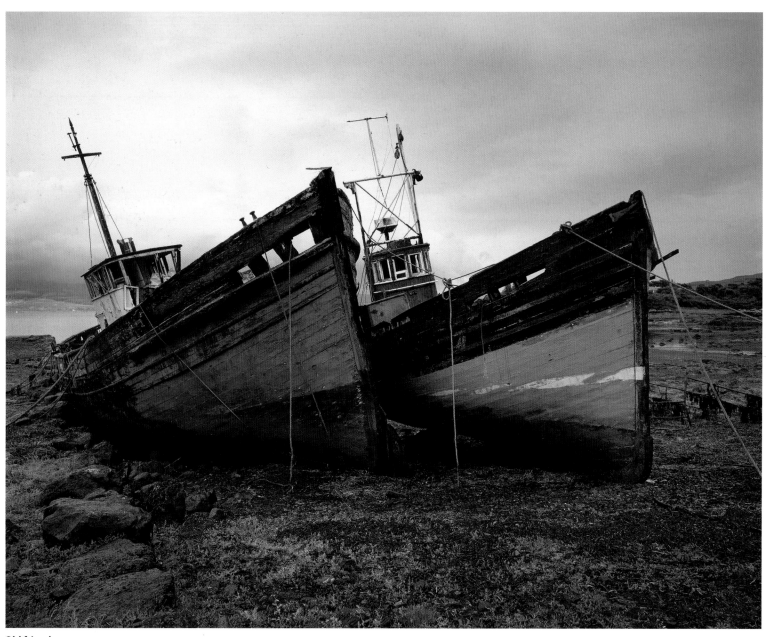

Old friends
Mel Foster [p150]

Mel Foster

In order to convey my vision through the photographs I make I try to trust my own reaction to a particular scene. In making a photograph I hope to intensify the feelings I have for what is in front of me by distilling the various elements of texture, form, colour and light in a way that excites me when I see the final composition on the ground glass. MF

Like music, I think photography lends itself to the expression of things that are not always easily explained in words, and I have found the process of analysing my own thoughts and reactions both challenging and stimulating. It has helped me to embrace and develop some aspects more fully, and disregard others – a sort of stylistic distillation. MF

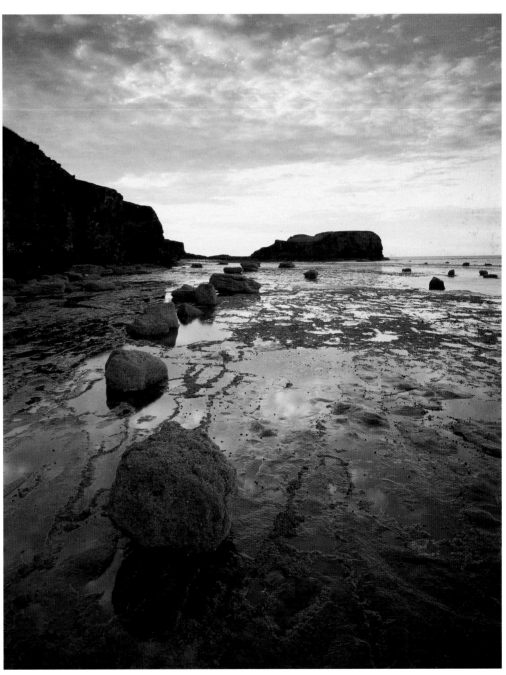

I think my photographs could be described as visual explorations. I love to create visual depth in my compositions whether through leading lines, patterns in surface texture, contrast in colours and light, or depth of field. MF

Stepping stones
Mel Foster [p150]

EE: Mel Foster asks 'How can we assess when our efforts to express ourselves and the essence of what's before us actually succeed and take us to the level of art?'

JC: *Hmmm, I feel unqualified to answer this question, as I don't feel I have yet reached art, that moment where the image transcends the sum of its parts. What I can say is that there are critical moments in the process of creating a photographic work of art, of which by far the most important is the 'seeing with the camera' stage, in the viewfinder or on the ground-glass screen. At that point you should have a strong gut instinct that you are onto something special. Then there is seeing the film for the first time, either as a negative from the processing tank, or on the lightbox as a transparency. In that moment you may realise you did it, that some alchemy of the photographic process has worked. Then there is the realization, after a period of living with the image (perhaps stuck on your office cork board as a work print, or as a tranny on the corner of your lightbox), that it has the ingredients, the balance and the depth that satisfy your sense of art. And in due course the feedback you receive from others may convince you that an image has struck chords elsewhere and has, quite literally, stood the test of time. Perhaps only then can you truly be sure.*

CW: *This question draws us into the deep quagmire of 'what is art?'. It seems to me that we can only approach our work from one direction (often hazy); a direction which will be dictated by personal inspiration and speculative exploration. How we extract the essence of the landscape that lies before us is basically a function of our emotional response to it. The esoteric nature of emotion is such that if we are able to convey even a portion of that primary response then perhaps an exchange and transference of sorts will have taken place, hopefully one that enriches all parties. It is a delicate business.*

DW: *Definitions of art are always tricky but I feel that the best description of art is that it should be a transformation of reality through the hands and mind of the artist. By this definition a photograph becomes art when it evokes a response in the viewer beyond a mere description. How do we know? Just ask!*

I'm learning to trust my own judgement more. This may sound like an odd statement to make, but it was only relatively recently that I realised that I hold the key to my own personal style. Of course, I must improve my technique so that it doesn't interfere with my interpretation of a scene, but ultimately imperfect technique shouldn't stop me having my own style. MF

Whitby wave detail
Mel Foster [p150]

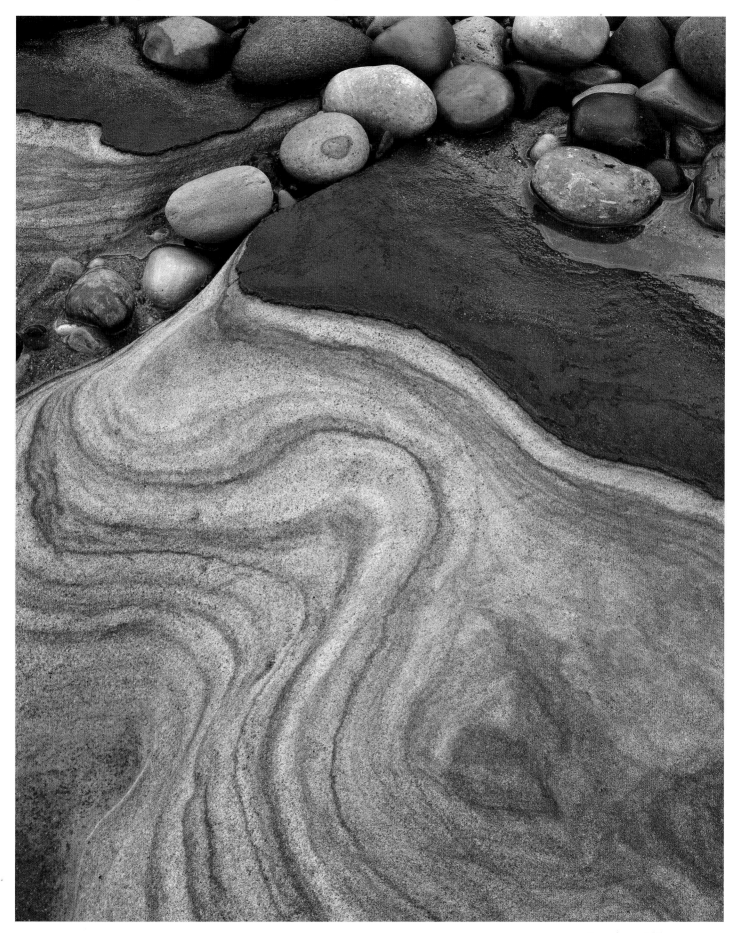

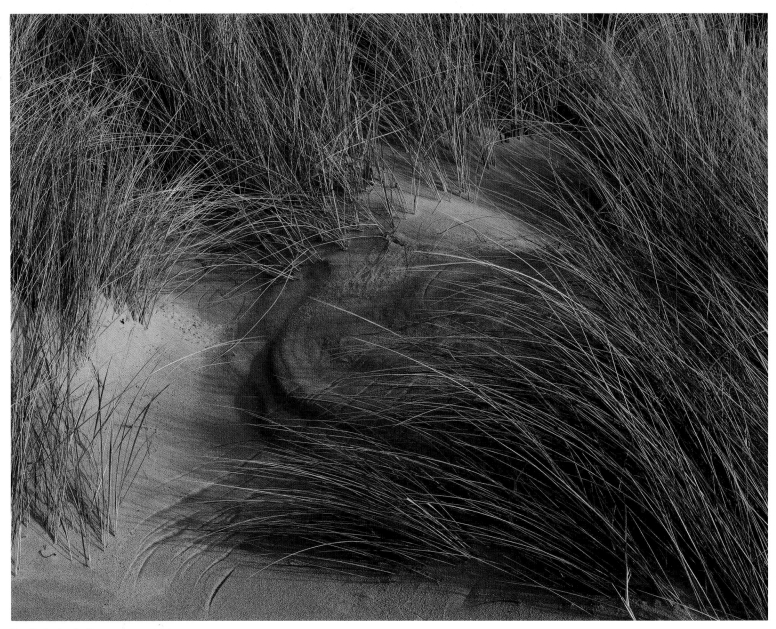

Brush strokes in the sand
Roger Longdin [p150]

Roger Longdin

Looking at the work of other landscape photographers is always very educational and one's emotions can range from the mildly critical to the ecstatic; though it is nearly always humbling to compare our own images to those of others, but then a true artist is never satisfied! RL

I don't think style either enhances or limits creativity, as one makes an image that appeals to the creative conception. If it falls within a particular style then that is just subconscious at the time of production. RL

Colours of Decay
Roger Longdin [p150]

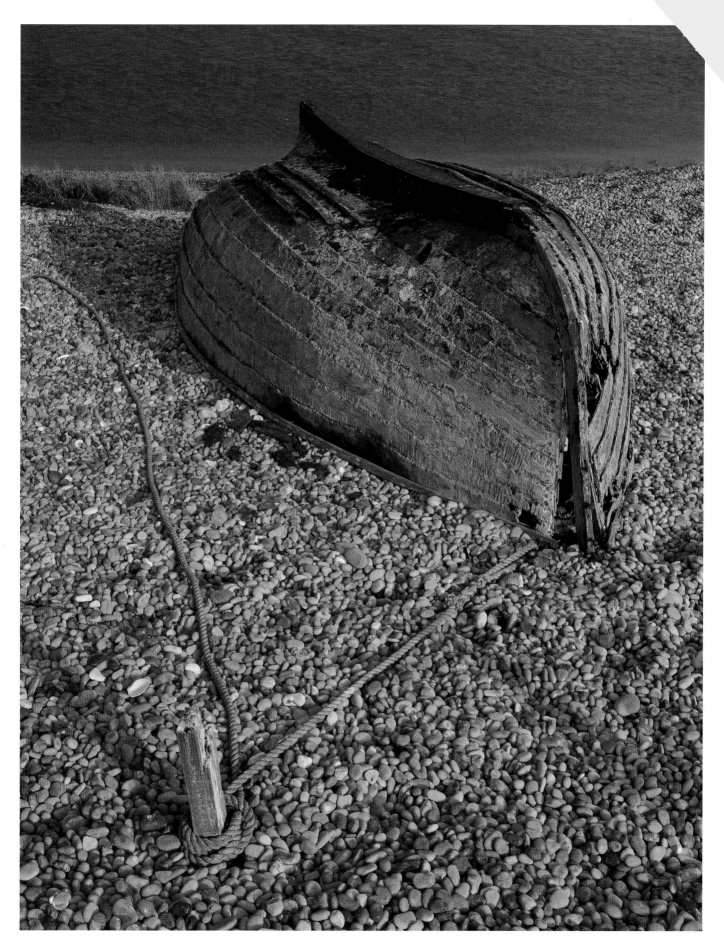

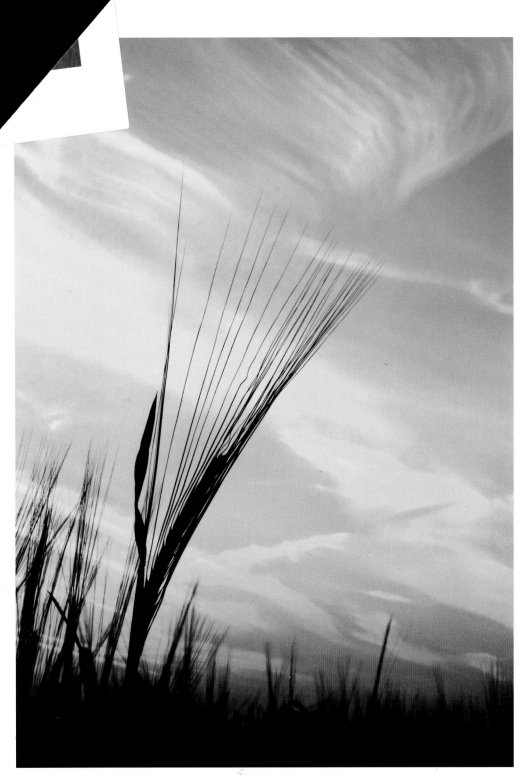

Barley at sunset
Peter Garbert [p150]

One could adopt a particular format or perhaps a particular film type and work within those constraints. This would be a sure way to establish a 'characteristic style' that would remain consistent and recognisable. Perhaps this would stimulate greater creativity, by limiting other options or ways of working, but on the other hand, it could have just the opposite effect! PG

Peter Garbet

Digital photography has enhanced possibilities for conveying vision and being able to explore different styles. Nothing can replace the ability 'to see an image', but for me, enhancement in post-production can really bring my original vision for the image to life. PG

Eli Pascal-Willis

When thinking about vision, I remembered the feelings I had when I was a child, the magical world I saw, unsullied by the common stresses of daily adult life. Vision to me is about drawing upon your inner child to reinvent the way in which you see the world, allowing your eyes to absorb the relationships that all the elements of the landscape have with one another. EPW

When I try to decipher the style I'm currently developing it is evident I enjoy taking photographs of subjects which have a link to my survival on the planet, one being trees and the other water. My subconscious emotional responses to these subjects helps me start to convey emotion through the image-making process. EPW

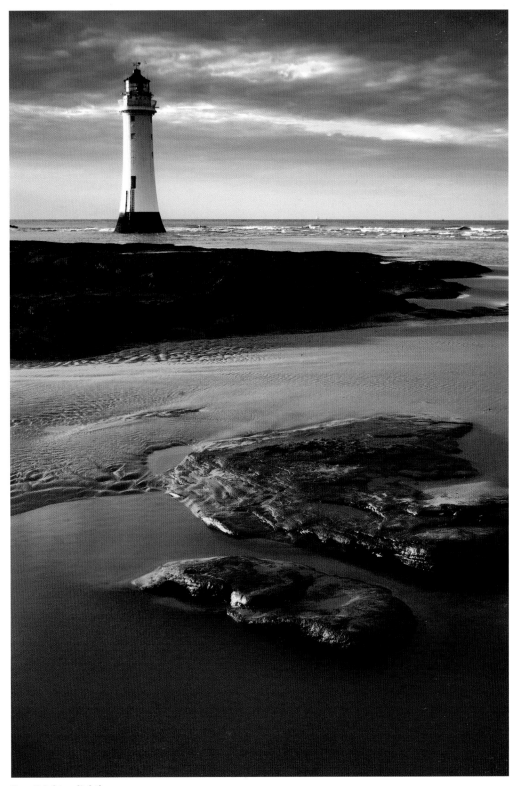

New Brighton lighthouse
Eli Pascal-Willis [p150]

James Kerr

If photography means more to us than just being a snap-shooter, it is almost certain that we will have been influenced by what we read, see or absorb from the countless images we encounter in our daily lives. For myself, a chance encounter with some images by Cartier Bresson in a weekend magazine many years ago sparked off a realisation that photography could create a reaction in me that went beyond just gaining pleasure and knowledge. From that moment on I was hooked. JK

Hampton Church Lucy
James Kerr [p150]

Dawn near Honington
James Kerr [p150]

Barford Bridge
James Kerr [p150]

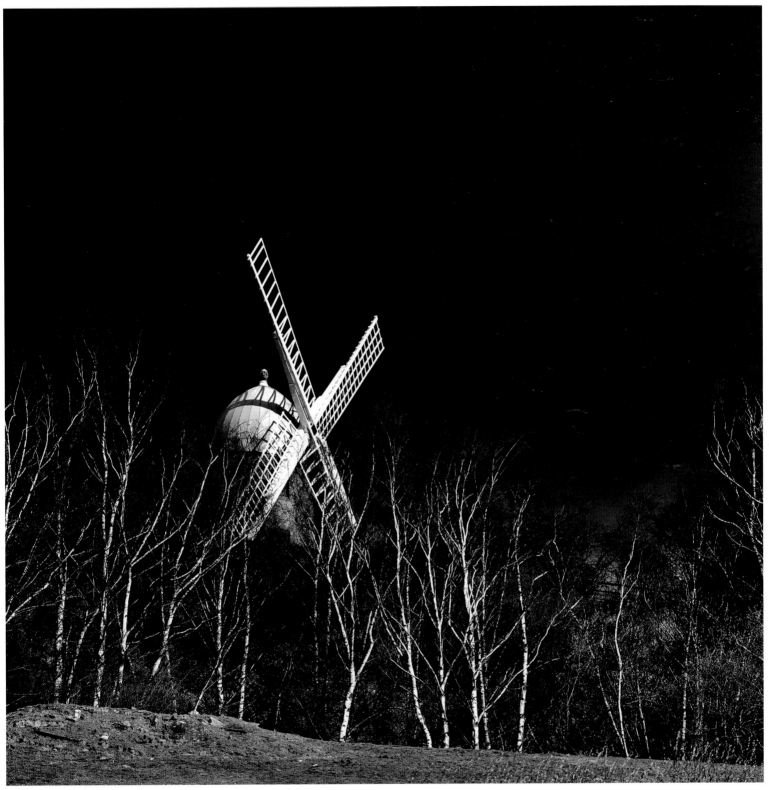

The windmill
James Kerr [p151]

As a relative newcomer to landscape photography I believe I have reached a stage of departure, I have absorbed many of the basic tenets of good picture-making but need more time before a definitive style can emerge. JK

Icelandic house
Simon Harrison [p151]

Simon Harrison

The direction in which I'm trying to develop my style is to capture subjects or scenes in such a way as to embed more meaning about the place I'm photographing. I think the best landscape images give the viewer some insight into the places they were taken; so now I'm trying to think more about what to 'say' about the subject I'm photographing. With the advent of digital I'm sure over the following years my style will evolve and expand in other ways I may never expect. SH

EE: James Kerr says, 'Digital photography has been 'a liberating experience…its immediacy has made me push the bounds. With film I usually played safe, always subconsciously aware of costs of film and developing.' In what way do you think digital would help you push the bounds?

JC: *Yes, this is potentially the greatest boon of digital, the stimulus to take risks and experiment where previously we would have held back. I agree, and would think that, if and when I do start shooting digital seriously, pushing the edges of the creative envelope even further would be the main benefit. In my case I would particularly welcome the opportunity to experiment more with focus effects, and close ups which is notoriously difficult to do on large format due to bellows compensation etc.*

DW: *Knowing that I'd made a correct exposure at the time would be nice but unless it was a digital back on a view camera I think that I would find the lack of control over perspective and focus too restrictive and frustrating.*

CW: *Oddly, whilst I currently favour film, the choice of medium is much less important than the struggle over the construction and integrity of the image. Digital is clearly hugely helpful to many photographers for all sorts of reasons. However, the one thing that I would need persuading of is that digital capture makes the whole business of composition any easier. Landscape photography is, after all, in the first instance about perception and the photographer has already made many photographs before the camera is raised to the eye.*

Marsch asks, 'How important is it to you that other people like your images? ... there images you've made that you don't like, but which have been 'successful' ...es of others? And vice versa, images you really like but which have failed to ...nterest from viewers?'

...: The latter point is the one that I have most interest in. Strangely, if an observer fails to be awakened by an image that I have great confidence in and one that gives me pleasure, then I am glad to say that their less than positive response does not undermine my conviction about that particular image. It is quite likely that I had invested a great deal in it and perhaps had very vivid memories as to how I felt at the time, no doubt joyful; so their lack of appreciation for the photograph cannot deprive me of the happy recollections that are stimulated when I look at it again. It was after all made entirely for myself to begin with.

DW: It's lovely to have one's ego stroked but ultimately I really only make images for me. Working in commercial photography there are always images that make money for reasons that I don't understand and usually those dearest to my heart make the least money. It's hard to separate the experience of making the image from the final result, so it's almost inevitable that there are some images that speak very strongly to their authors but not to the audience.

JC: Yes, to me it's important that other people like my images, and especially when I was younger I learned a lot by observing the reactions of others to my work. But it is not all-important. If I don't like an image I don't 'release' it for public 'consumption' anyway, so it is hard to answer this second point. I have had images that have been commercially successful which I would not rank among my best work, but you expect that because it is often work that fulfills an expectation that is commercially successful, rather than something which is ambiguous, enigmatic or challenging. And yes, I do have images that I like which don't necessarily appeal to others. But these days that doesn't bother me unduly.

Alan Reed

Without vision the photographer is dependent upon opportunity, which is in itself no bad thing; but style requires more than opportunity, it demands some knowledge of what one is trying to achieve and of how one is going to achieve it. My vision includes simplicity, composition and light. AR

Waxham beach
Alan Reed [p151]

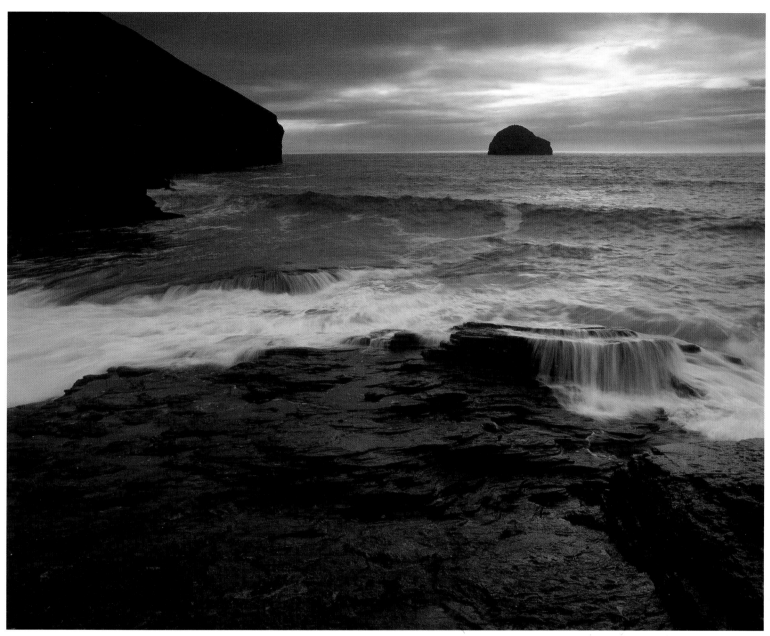

Slate and surf
Ian Laker [p151]

Ian Laker

> I don't think I've yet achieved a consistent or recognisable style, and I've been taking photographs, on and off, for thirty years! Only during the last ten years have I concentrated on one or two genres of photography in my personal work. IL

> My vision is largely based on two approaches. The first is related to the juxtaposition of natural and human elements in the landscape, both urban and rural. Secondly, I enjoy the effect of not only direct but also indirect light on the landscape. I hope my personal work is starting to evolve beyond merely recording the scene before me in a technically proficient but anonymous way. IL

Fence post and dune
Ian Laker [p151]

EE: Paul Gallagher thinks that 'maybe style is something best described by someone else.' Would you agree? And, if so, who has best described yours? And who else would you like to describe yours?

CW: *Perhaps there is some truth in this. Might it be that analysing one's own style is as hard as any other form of introspection? It is impossible, for example, to perceive oneself in the way that others may see you; by the same token one's style might be too opaque to oneself for us to characterise it. I am unable to say who has best described my style. Perhaps, if an individual is good enough to acquire my work then that is sufficient. It is tremendously encouraging when this happens and perhaps can be seen as indicative that this small exchange has had some meaning.*

DW: *Yes, I wholeheartedly agree. I find it impossible to objectively describe my style because it is simply the way I see. I'm not sure that I'm happy with the way that anyone has described my style but I'd like Eddie to have a go... [Ed: in* Landscape Beyond *– David's next book, I hope…]*

JC: *A nice thought! Yes, I do agree, I think it is very difficult to describe your own style, for we are too close to be objective about it. In all honesty, although lots of people have said to me 'I love your pictures' (thanks very much), no-one has ever described my style to me. Of course, you would like someone to describe it who was bound to be really, really nice... my Mum perhaps! Seriously though, the most valuable description would be to hear back from one's contemporaries and peers. Leaving aside my three colleagues here, David, Charlie and Eddie, I think I would like to hear a description from John Blakemore or Paul Wakefield. However critical their description, I could live with that, and I think I would learn from them.*

Spring wood
Roger Creber [p151]

Roger Creber

Photographic vision is the strategy and photographic style is the tactics.
Vision is the Why and style is the How.
Vision is also the Menu and style is the Recipe. RC

Perhaps my style has changed more down the years than my vision. It has zoomed in over the years from wide-angle to telephoto. Perhaps in the future I may zoom out again. The success or otherwise of the final picture is really what counts, rather than how you get there. So, does this mean that vision is more important than style? RC

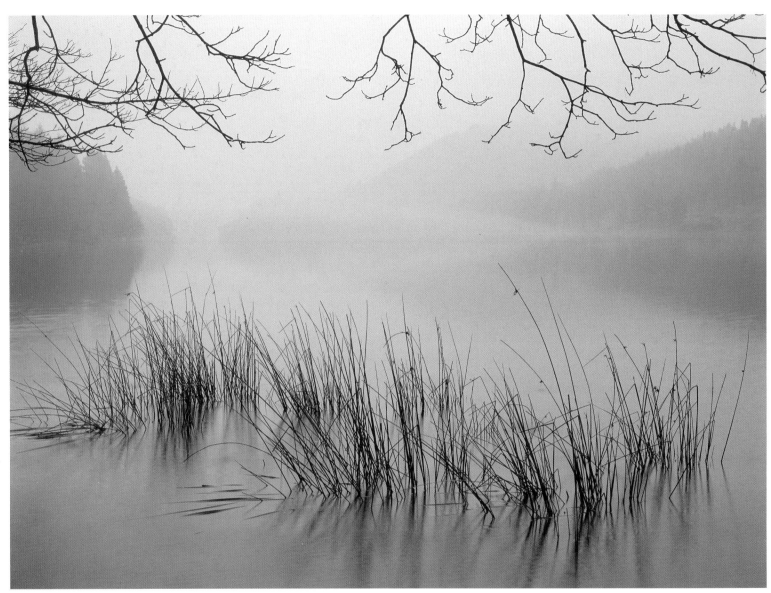

Lady Bower resevoir
Keith Urry [p151]

Keith Urry

Style enhances creativity but we should be careful not to get stuck too much on one particular way of working. I have known times when I have gone out and felt I have exhausted a location, feeling an almost total photographic block only to return at a later date and find fresh images that I could not see before. KU

EE: Nigel Baker says: 'When developing our personal style an open mind is essential.' How do you maintain an open mind or, now that you are well established, do you work within self-imposed parameters?'

CW: *I was not aware of 'keeping an open mind' in the early stages of my photography. I was struggling with insecurities about each image and would have been glad to have had the security of some 'self-imposed parameters' in the first two years. I knew then that I needed precision of execution, a sense of order, cohesion and I guess I had some rudimentary, if deeply subconscious understanding of the balance and design that a photograph should have. I knew that, on the whole, I wanted to have directional light and was aware that I was beginning to develop a sense of discipline, but apart from that I was generally in a state of flux and remained, healthily, photographically very impressionable.*

DW: *I think I maintain an open mind by not having any fixed goals. I treat photography as a voyage of discovery and rather than working within boundaries I'm interested in the bits just beyond the edge of the territory I know.*

JC: *My parameters are imposed in no small part by the camera that I use, and I accept its limitations because I feel that the enforced discipline, the fact that I cannot work in an opportunistic ('Wow! that looks good!' Snap!) style is an inevitable by-product of the large-format camera. However, I do aim to maintain an open mind when it comes to my subject matter, and my belief is that the landscape and the light guide me, rather than my vision imposing itself on the situation. You could say, I am 'subject to light'. And since I do subscribe to a belief in the subtle effects of language, I try to avoid the terms, 'take', 'shoot', 'shot', 'snap', 'grab', and 'capture', all of which are in common use in photography. To me, they imply an exploitative relationship with the subject matter.*

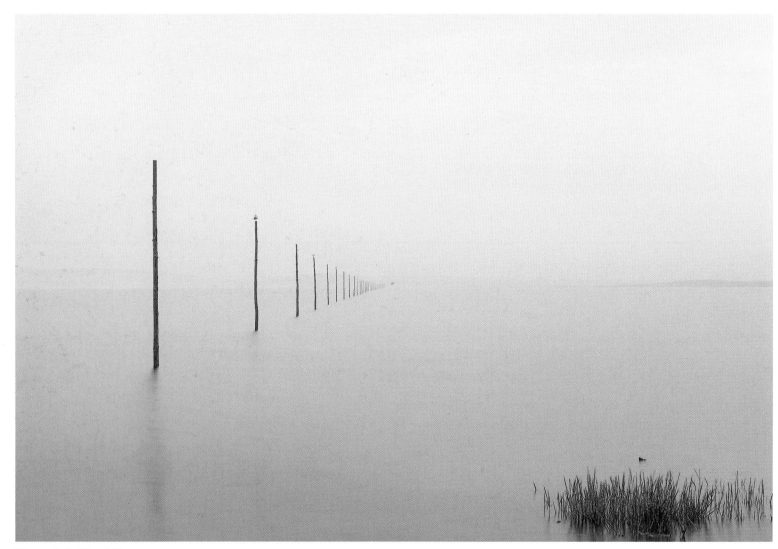

Silence, St Cuthbert's Way
Mike McFarlane [p151]

Mike McFarlane

I only bought my first camera and started taking photographs four years ago, but the purchase of an ultra-wide-angle lens two years ago was when I discovered a style of photography that suits the way that I see the world. From an early age I liked to be in places that no one else went to, often places where people weren't meant to go and if this meant scrambling down a cliff or over a wall, then so be it, I just had to be there. Thus the ultra-wide-angle lens, which allows me to show the details at my feet and gives a sense of immersion in the scene, an ability to walk right into the photograph; at the same time it allows me to show the context of the details, creating a photographic style with lots of foreground that reflects my world view. MMcF

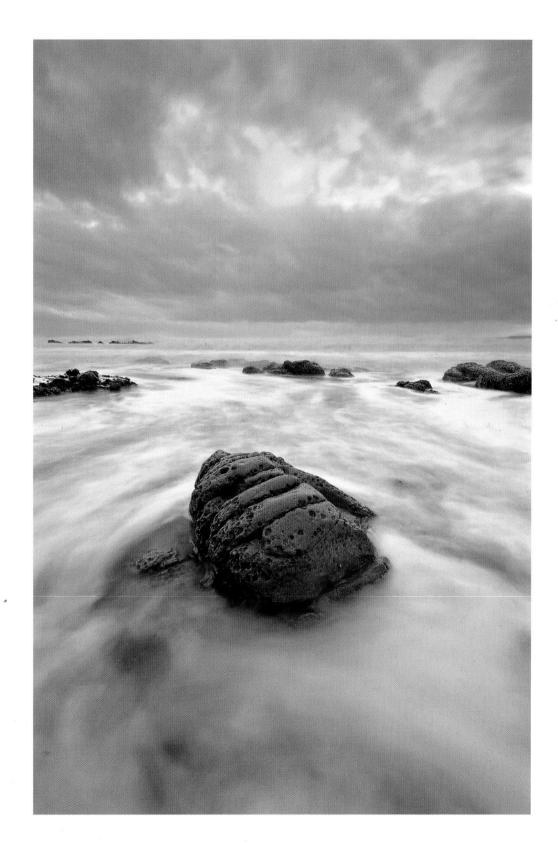

My style also tends to be quite graphic and places great emphasis on shape. Some compositions will form naturally and intuitively in my mind or in the viewfinder (a tripod is great help here as it allows me to study the composition over time). I find that formal rules help when intuition fails. Maybe it is the engineer in me. MMcF

Lonely rock
Mike McFarlane [p151]

Sometimes I feel my strong style emphasising natural beauty and utilising acres of foreground is like a straitjacket. I have tried to break free. Lately, though, I have relaxed a little and let myself look around with open eyes again. 'Silence, St. Cuthbert's Way' is for me a delicious result of just looking around with nothing particular in mind. MMcF

EE: Paul Webster asks, if at any point your work has fallen into cliché?

JC: *Probably! I am conscious of the 'loads of foreground – possibly big, round boulder – dramatic sky' cliche. However, these characteristics all derive from 'tactics' that I use to achieve certain qualities which fundamentally are my vision of the landscape. Harold Evans said, 'If your pictures aren't good enough you're not close enough.' He was referring to news photography, but I apply it to landscape photography in a metaphoric sense, of being close (emotionally) to the subject. The foreground aspect reflects my desire to get 'into' and around the forms, colours and textures that surround me. The wide-angle lens is often in use here. It helps me to feel physically (and emotionally) closer to that aspect of the place, whether it be wildflowers, boulders, sand details, ice, flowing water, whatever. It also helps me create a feeling of depth, and provides a place from which the eye reaches out, in the imagination, to the landscape beyond. It is a sort of doorway, or window, or springboard to the world. Yes, I also like skies with drama. I feel that clouds are a reflection of the soul, and that a plain blue sky is like a person with nothing to say. A sky with a balance of different textures and shapes and colours is like an interesting person who has had a life worth talking about. I also believe that, if the sky is in the composition, it should be making a contribution to the effect of the picture, and not just be there because it is traditional to have the sky in a landscape vista. Finally, the round boulder. Many years ago, when I was a young assistant in America, my boss and mentor Mike Mitchell, made a photograph in the studio of a geographical globe resting gently on sand in an imaginary desert landscape. The beauty and symbolism of that image has haunted me and has proved the inspiration for my round boulders. I find myself hypnotised by them. The notion that spherical forms represent the earth, and our ability to see our wonderful planet from the vantage point of outer space in all its cosmic beauty, is perhaps too fanciful. But I do believe that the sphere is a universal symbol of wholeness, of completeness, of molecular and atomic structures, and of course the shape of stars and planets. In any case, spheres just work for me.*

The miracle of life
Mike McFarlane [p151]

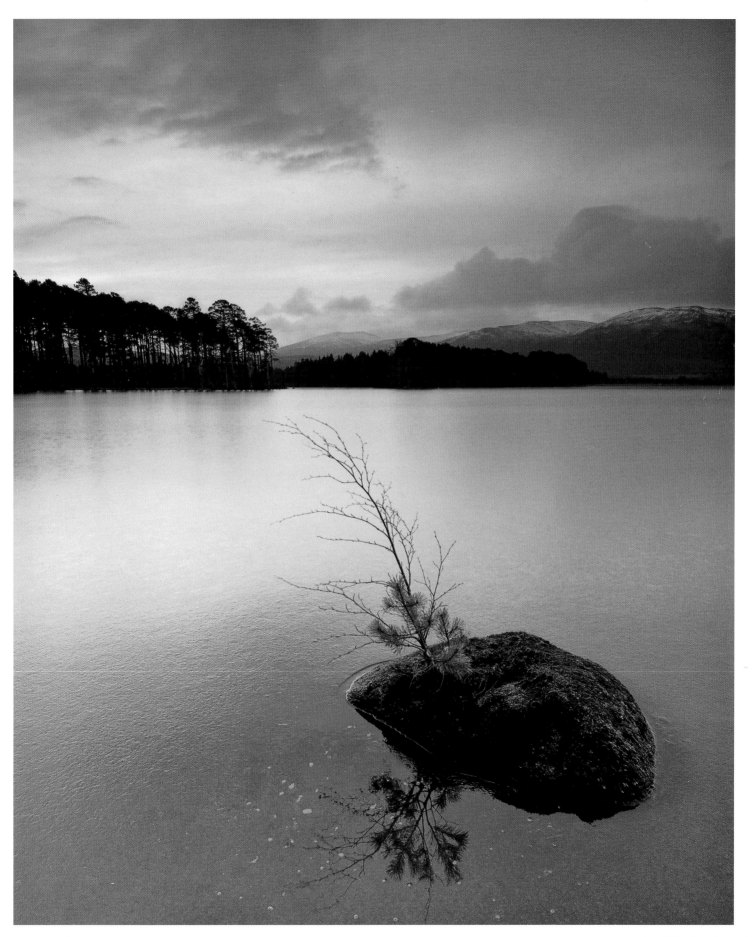

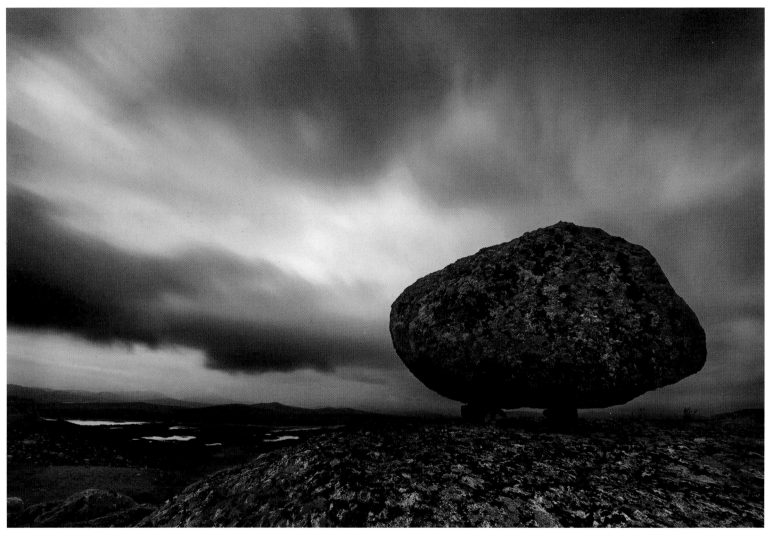

[No title]
Sylvestre Popinet [p152]

Sylvestre Popinet

Vision is, for me, an inner state. It's a philosophical point of view on the world. Why make photographs? Perhaps to be a human is to be a storyteller. As photographers we rely, first, on the view to tell our stories. I just try to be here and now, with a peaceful open mind, with sufficient materials and technical skills to tell the story to someone else, so they can share and enjoy the moment. SP

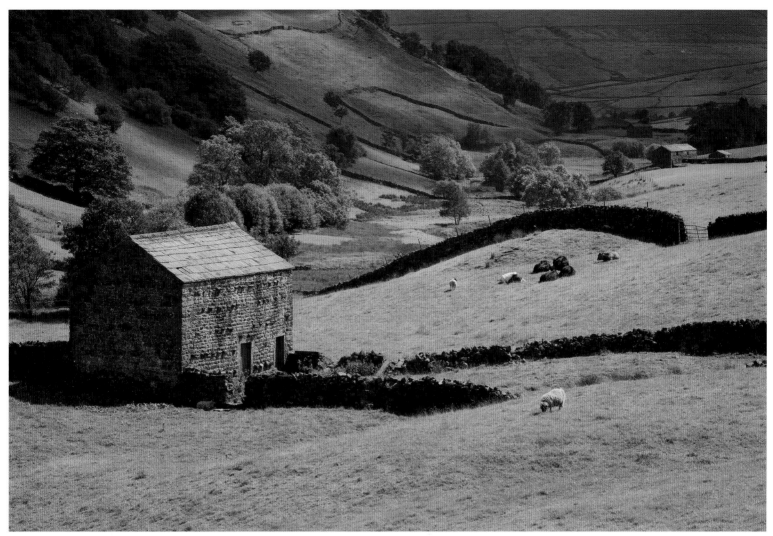

Swaledale field barn
Julian Parker [p152]

Julian Parker

My style is the product of my photographic choices, coupled with how I see a photographic image – my vision. It is defined by: my equipment choices; precedence being given to quality of light; subject; an inability to photograph, to see, close to home – an unfortunate blind spot; a preference for pre-planing or scouting locations in advance; 70% colour and 30% black and white; a favourite combination: water, hills and light; a willingness to crop an image at times, but only comfortable cropping to an established format/aspect ratio; as I try out new creative approaches, and they succeed, I add them to my 'creative kit-bag'. JP

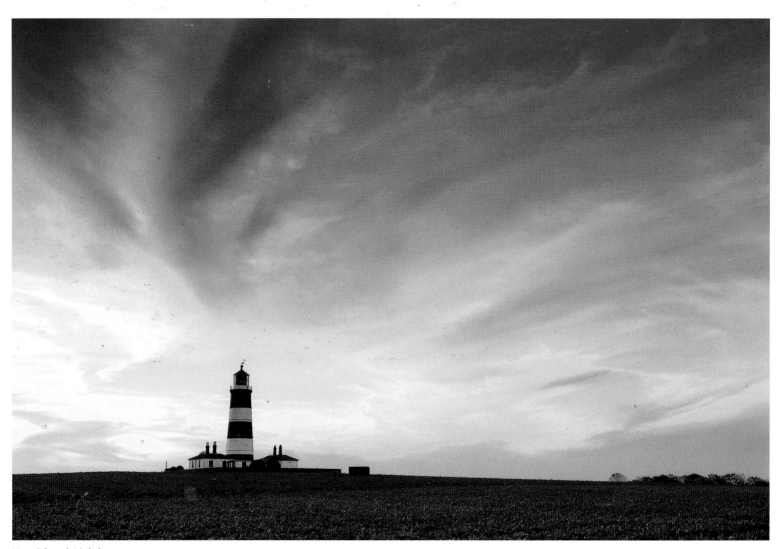

Happisburgh Lighthouse
Ian Stacey [p152]

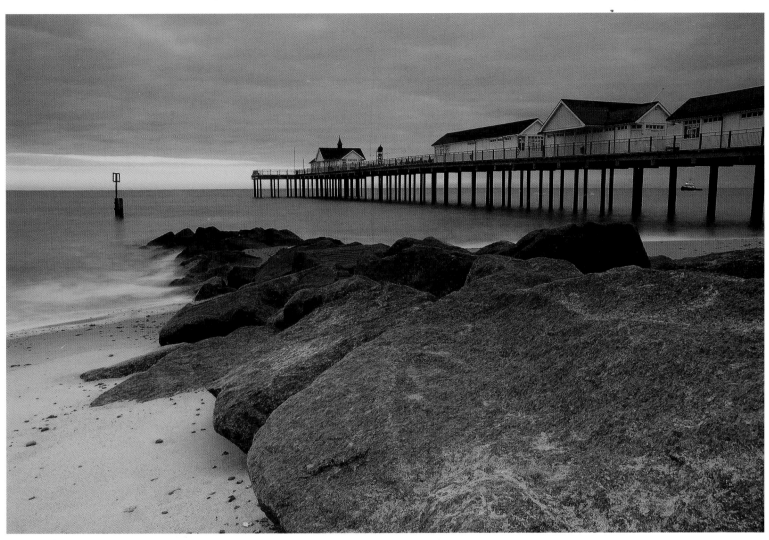

Southwold Pier
Ian Stacey [p152]

Ian Stacey

I would like to think that I don't have a specific style and that every picture I take has a different style, based upon the location and subject matter. However, writing this piece has made me look at the pictures I take and I can now see a certain style emerging. The images I submitted were all taken in or around coastal areas. In most of them, the main focal point is not large in the frame. This is becoming my style of landscape photography. As with vision, style has to evolve, otherwise our pictures would become stale and possibly boring. However, we have to recognise our style in the first place in order for it to evolve. IS

EE: Andrew Barnes asks 'Do you ever feel you lose your artistic/ photographic vision? If so, what do you do to regain it?'

DW: *There are certainly times when I find it hard to make images and these are usually when I've not relaxed into a receptive frame of mind – it often takes me a day or two at the beginning of a photographic trip before I'm receptive to images. Getting frustrated only makes it worse so I just resign myself to the possibility of not making an image but carry on studying the landscape. The vision always returns!*

Jonathan Horrocks

I suspect that my own vision owes a good deal to the fact that I studied maths at university, and hence I am drawn to very strong geometric shapes and images. I am particularly fond of leading lines, a compositional element that I probably completely over-use! JH

In some way you want to provoke in people something of the emotional response you felt when viewing the scene in front of you. For me this is very much a learning process, I see it as the 'Holy Grail' – the skill that separates the successful professional from the keen amateur. This is an area where mastery of technique is essential. Once we reach a point where exposure and the understanding of light has become second nature and we have the experience of taking both successful and unsuccessful photographs we can think purely about the image and the vision we wish to convey. This is what I aspire to be able to do with my photography and I expect it to take a long time for me to get there – if indeed I ever do – but I will have a lot of fun along the way. JH

Another rainy morning
Jonathan Horrocks [p152]

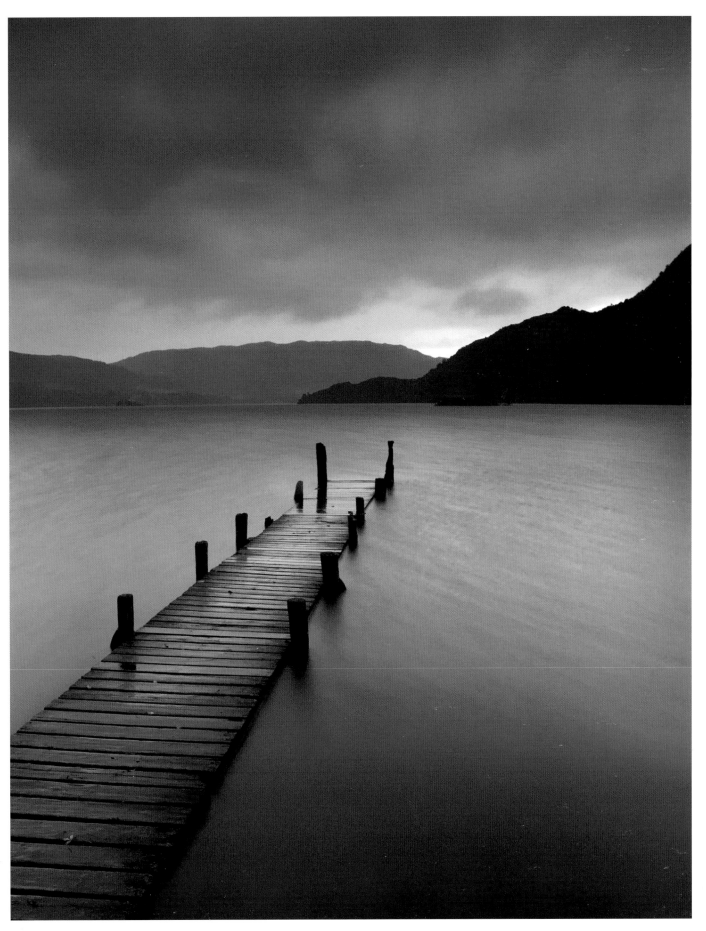

Vision is the ability to anticipate the possibility of an image. Before travelling to a new area I try to imagine the types of pictures I hope to take, although this rarely works out in practice. You have to be able to react to the conditions with which you are faced at the time. Nowadays, I try not to rush or take in everything I see. I take pictures to satisfy myself and if others enjoy them it is a bonus. I therefore tend to take pictures with a similar feel in similar conditions. GC

Blue Mountains
Greg Covington [p152]

Greg Covington

Many of my photographer friends have a style which I can recognise. As I get to know these people I understand why their style has evolved. My photography has inevitably changed over the years. You cannot take the same types of image for ever. I once had to write a philosophy of my photography and I based it on two words: being there. Looking at the images I have submitted, I can see that they have a common thread running through them. There is a simple use of colour, mostly muted, and simple composition. I try to capture the mood of the situation. GC

STYLE EXPRESSES VISION

DAVID WARD

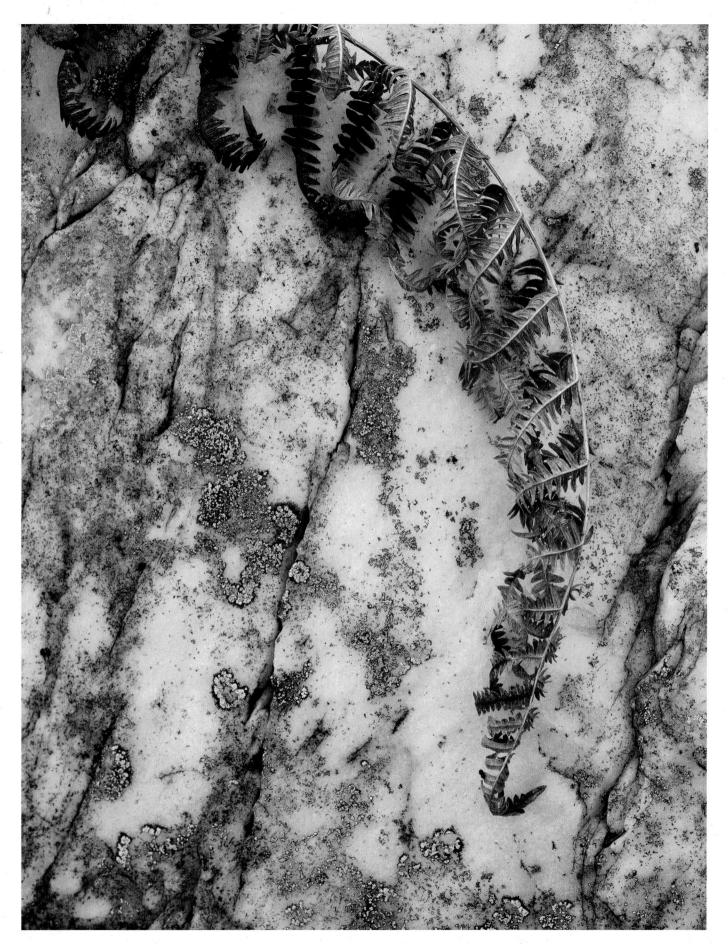

My vision is bound up with who I am, it's based on my view of the world and it inevitably evolves as my view evolves. I convey my vision by my choice of subject matter (which springs from the way that I think about the world) channelled through my technique. DW

David Ward

Mesquite Dunes dawn (2003)
One of the advantages of using a view camera is that one can make a standard lens shot resemble an image made using a slightly wider lens through the camera's control of perspective and plane of focus. This is in all other ways a quite standard representation of the dunes; the perspective is normal – neither compressed nor exaggerated – and the framing gives a sense of particular place and time. I think that this is a good photograph, but not a great one. It became apparent to me around this time that photographing a view in this way I was never really going to show my vision. This image could have been made by any number of good photographers; there's nothing about it that says 'David Ward'.

THE CONCEPT OF STYLE is more problematic for me than vision. I define style as the way in which we choose to express our vision, it is the product of a photographer's way of thinking and his aesthetic concerns channelled through his technique. Style and vision are indivisibly bonded to each other; photographic style is rooted in the individual, it is deeply personal.

Because photography is primarily a descriptive medium, photographic style is less distinctive than, say, the manner in which a painter applies colour to his canvass or the way a writer composes his sentences. The photograph's description of reality seems straightforward, effortless and unmediated. It seems style-less. We accept photographs as plain, truthful depictions and as a result the photographer almost becomes invisible. In most cases, and especially in landscape photography, a photographic style is not about overt mannerisms such as tilting the camera, using extreme wide-angle lenses or heavy filtration. This can lead to stylisation, a crude way to attract the viewer's attention without revealing anything of the photographer's concerns. These images have instant impact but no depth. We might know that a photographer favours long lenses or early morning light but this does not describe their style. Other photographers also favour these things but that doesn't mean that they have the same style.

Style is the single attribute that proclaims the author of the image. But, strangely, style is, like the photographer, invisible in a single image. It would be a foolhardy person who ascribed a single unknown image to Joe or Charlie with absolute certainty, yet when we see a group of their images we are usually able to confidently identify the author (this despite the fact that what they have photographed may well have been photographed on numerous occasions by numerous other photographers).

PHOTOGRAPHIC STYLE springs from the individual photographer's intellectual and aesthetic concerns, it is not a simple matter of surface appearance. We are all aware of images that are made 'in the style of' another photographer but these lack conviction. The originals sprang from the photographer's spirit of enquiry or deep knowledge of a subject but the pastiche only seeks to be visually similar without addressing the underlying ideas. Trying to copy the style of another photographer is, leaving aside any technical knowledge we may acquire in the process, a pointless exercise.

Mesquite dawn (2006)
This is much more typical of my current vision and style. As my vision has developed over the last few years I've begun to move away from the particular toward images that are less of a place and more abstract or iconic in nature. I've also consciously tried to make compositions that are more my way of looking and not weak imitations of how others might see the same scene. I like strong, graphic lines and working on the ridge of a sand dune provides plenty of possibilities. It was crucial to me that the sinuous line of the ridge touched the edge of the frame on the left before turning back into the composition and taking the viewer with it.

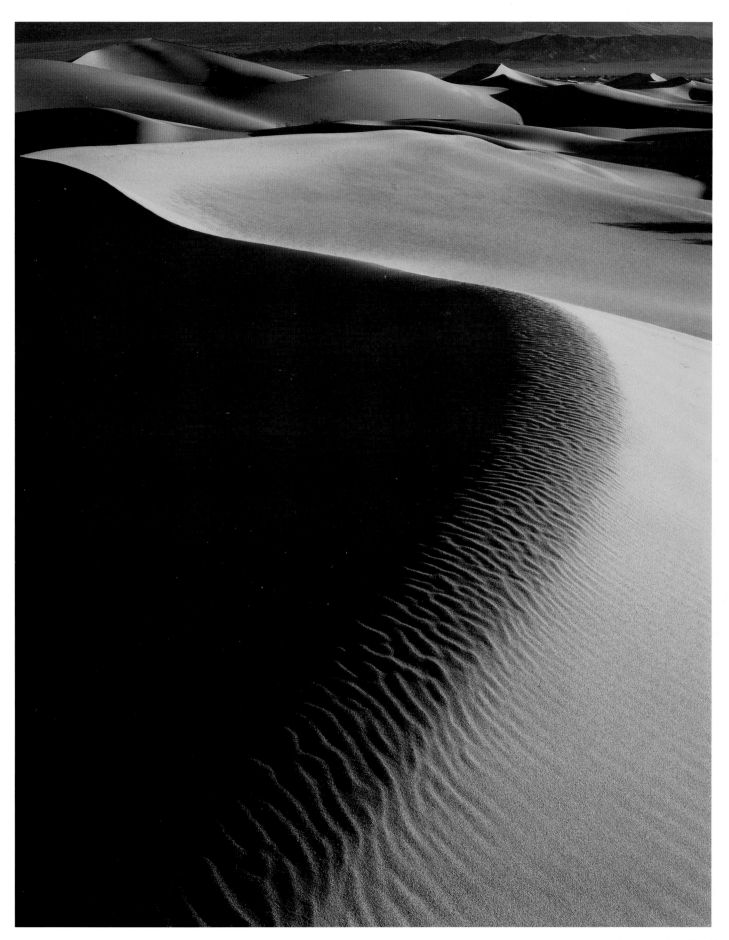

Photographic vision is quite simply the way in which we see the world around us; it is the combination of the way we think about the world and the way that this affects what we find visually exciting. DW

I HAVE BEEN TOLD that I have a distinctive style but I would find it hard to describe because it's a clear as water to me. The way I compose seems as natural as walking or breathing. It is easier for someone else to describe a photographer's style not only because they have the distance needed for a degree of objectivity but also because they can see the differences between their own view of the world and that of the photographer.

My personal outlook on landscape has changed greatly in the last eight years. When I first made landscape images I was concerned with describing the scene in front of me in a straightforward way. I merely wanted to describe it as well as I was able in order to convey my feelings to the audience. I'm now more concerned with finding reflections of my mental landscape in the solid geography. This shift has led toward me making fewer vistas and more abstract images.

A photographer's style shouldn't be static; it should evolve. We can quite easily see this process taking place in the work of other artists, from Turner to Picasso, but it may be less apparent in photography for the reasons I outlined above. The evolution of a style should be a natural process as the photographer's mental outlook changes and as their technical expertise grows; it should never be forced.

Stylisation can inhibit creativity but style doesn't. Style is the product of our creative thought, it is limited only by the breadth of our own mental and artistic horizons. Stylisation is the application of a technique, whether it be purely photographic or compositional, merely for its own sake. In other words, style is intrinsic and stylisation is extrinsic.

Rock garden
My visit to this area of northern Arizona was my first experience of desert and I found the experience quite overwhelming. However, in retrospect I feel that the images I made were quite mundane illustrations. They are technically fine, the light is even quite good but they don't stand out from a hundred other images of the same place. This subject is so strong that it overpowers the photographer's vision of it. One might try and force this 'stand out' quality by using a wide lens but that would just lead to a stylised image rather than to developing a style of one's own. The real trick is to find your own viewpoint, to quite literally to stand in a new place. Sometimes this means not taking 'The View'.

The Wave
The Wave may not be the most photographed geological feature in the world but it ranks very high in most landscape photographers' top ten locations. Disappointingly, most seem to make the pilgrimage only to repeat the same wide composition showing the complete formation. The Wave is a truly stunning piece of geology but why travel all that way to make somebody else's picture? I think that photographers are sometimes afraid to come away without 'The View'. I would be disappointed to come away without 'My View'. If photography is about self-expression then that's exactly what we all have to do; express our own feelings in our own compositions.

Hafrafell, Iceland

Photographs lie in a thousand different ways, this one lies by appearing to be serene when the act of making it was anything but! The 5X4 format doesn't lend itself to grab shots, usually by the time you've seen something the opportunity has gone. On this occasion I managed to make a single exposure before the fleeting arrangement of cloud and sunshine on the mountain disappeared. The composition was entirely instinctive and only afterwards did I notice the echoing of the clouds and shadows in the shape of the stream in the foreground. I think that we largely learn to see by these chance revelations. Once primed our mind seeks out similar opportunities and we find ourselves seeing new connections and making different kinds of images. In this way our vision and style unconsciously evolve. Forcing things never works, leading only to mannered images.

ANYTHING THAT CAN BE IMAGINED and realised on digital could also have been realised on film so I feel that, apart from allowing people to review their work more quickly (and thus to learn the craft more quickly in terms of technique and composition), digital photography's effect on vision has been neutral.

WHEN I THINK OF JOE AND CHARLIE'S WORK, two images spring instantly to mind; Joe's photograph of the beach at Barra (from *Scotland's Coast*) and Charlie's oft-imitated image of round straw bales in golden light. I love both of them for their particularity (they could only have been made at the exact instant at which the shutter was pressed), their simplicity and the subtle way in which the cloudscape mirrors the foreground. Each is my favourite image by Joe or Charlie. I think that this reveals more about my outlook than the photographs necessarily do about Joe and Charlie!

Do Joe, Charlie and I have recognisable styles? Our styles spring from the subjects that inspire us. Superficially one might describe certain compositional approaches as belonging to Joe or Charlie but that would do their photography an injustice. I think that photographers are liable to be typecast in the same way as actors or writers, 'Oh, they only shoot at the beginning or end of the day…'. This typecasting can be very damaging for a photographer as it can place a creative constraint in their work.

Aspen grove

I'm now trying to apply the lessons of composition that I have learnt working on fragments of the landscape to the wider landscape. For me this means representing the wider view in an abstract manner; treating larger elements, such as the woods here, as simple shapes to be arranged in the frame. The snow obviously helps with this process, providing a 'blank canvas' on which to compose. Using the longest focal length lens that I had also helps – the inevitable elimination of foreground flattens the perspective adding another level of abstraction.

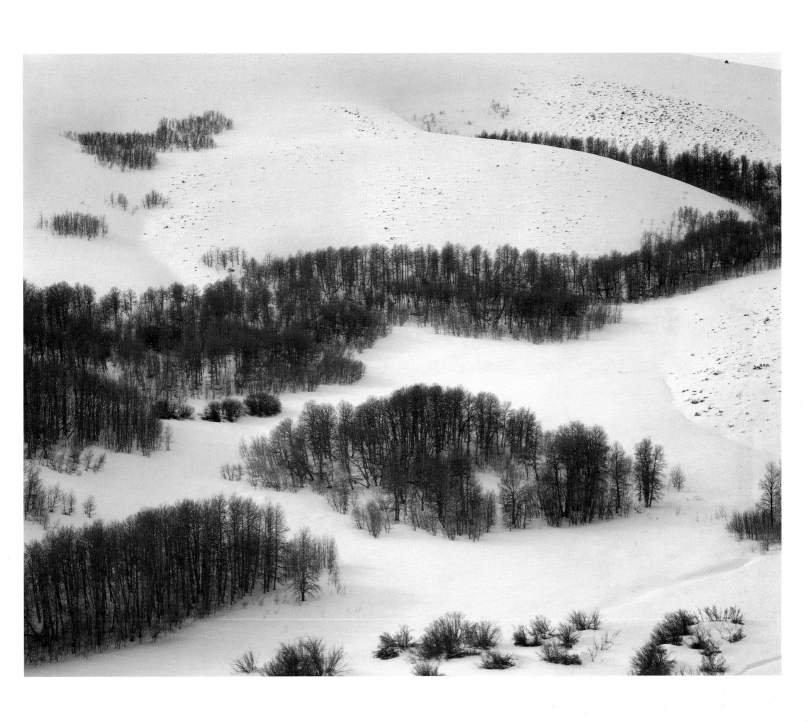

I find it impossible to objectively describe my style because it is simply the way I see. I'm not sure that I'm happy with the way that anyone has described my style. DW

Virgin River reflections

I'm not very keen on perfect reflections on water showing an inverted mirror image of the world above and beyond it. To me they always resemble Rorschach test inkblots rotated through ninety degrees. Perfect reflections offer an easy, but nevertheless beguiling, symmetry that tells us nothing new about the world. I prefer to photograph moving water as a distorting mirror, letting it throw up new realities. An exposure time of a second or more causes further abstraction and adds a certain frisson of uncertainty to the process; I never know exactly how it will turn out until the image is on the lightbox. This was probably my first image of reflections that I felt really worked..

But style is something wider than this stylistic description. Neither Joe's nor Charlie's inspirations are as narrow as they may have been portrayed, so the variety of their imagery is wider than one might expect. If I had to define their vision a,nd style I would say that Joe's approach is one of presenting the landscape in a naturalistic way, without using obvious formal concepts. Timing is a crucial issue for Joe, many of his images rely upon the momentary fall of light – something that is very difficult to capture using a large-format camera. Although he makes superb intimate landscapes he seems more comfortable with the wider view, perhaps because his avowed intent is to lead the viewer on a journey through the joint space of the landscape and image. The resulting images are complex but balanced and self-contained.

Charlie's images are more obviously composed than Joe's. But they appear anything but contrived; seeming, superficially at least, to be effortless whilst actually having deep formal concerns. They are often the product of looking very hard at seemingly mundane subjects. Many of the early 6X6 images have quite striking and unusual compositions which create a tension in the frame. He likes symmetry and the juxtaposition of man-made forms with natural forms.

May Beck

Many photographers plan their shoots, they have specific target images that they want to achieve and these may be planned rigorously; time of day, time of year, angle and even lens may be decided upon beforehand. I will, more often than not, travel to a location with simply the hope of making an image but not in the expectation of making a specific image. There is a picture of May Beck by Joe which I've long admired and I decided to visit and see what I could find. After about an hour of wandering and looking I came upon this scene. What attracted me to it was the split between the reflection and the clear water allowing me to see the sharply defined skeletal leaf trapped below the surface. There's a sense of a mystery revealed and an interesting juxtaposition between sharpness and the flowing water.

GALLERY FORUM – 3
Photographers discuss vision & style

My vision today is influenced by light, pattern, seeking freshness and avoiding what my experience has told me won't work. I am sure that if I were to write again in twelve months time I would add to this list as I explore and develop further aspects of my vision. I am only beginning to be aware of fundamental questions like 'what am I trying to say with my pictures?', 'what is creativity?' and 'what is cliché?' Jon Brock

Showers over Uist
Richard Childs [p152]

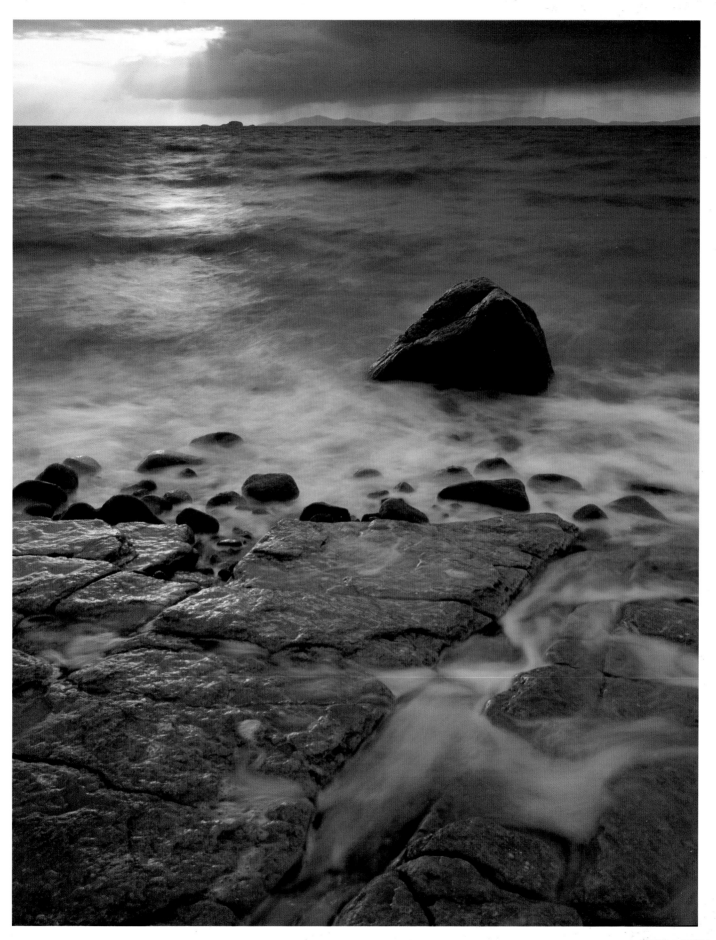

Nigel Halliwell

My vision and style might be best defined in terms of my compositions. With landscape, I look at the foreground area as the most important part of the image. To me it ties in the whole picture and I try to ensure it makes an impact as it is the nearest and usually most detailed part of the image. This approach is often referred to as a 'lead in' to the picture, but I attach more importance to it than that. I prefer to think of it as the 'lead out', as sometimes the foreground can take up a large proportion of the image. NH

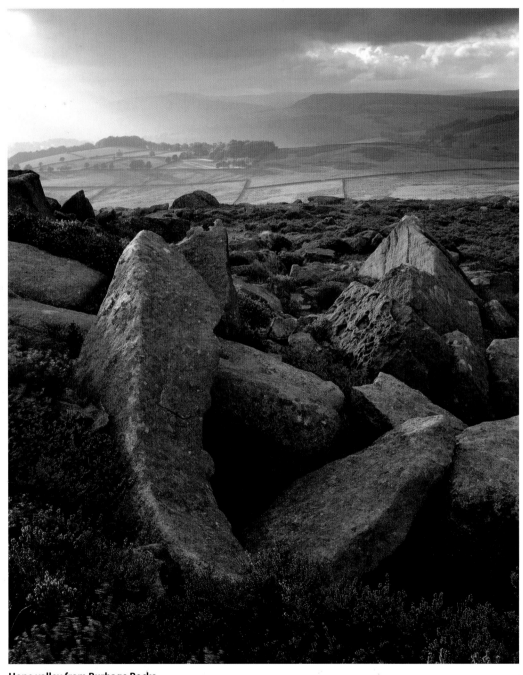

Hope valley from Burbage Rocks
Nigel Halliwell [p152]

Falling Foss
Nigel Halliwell [p152]

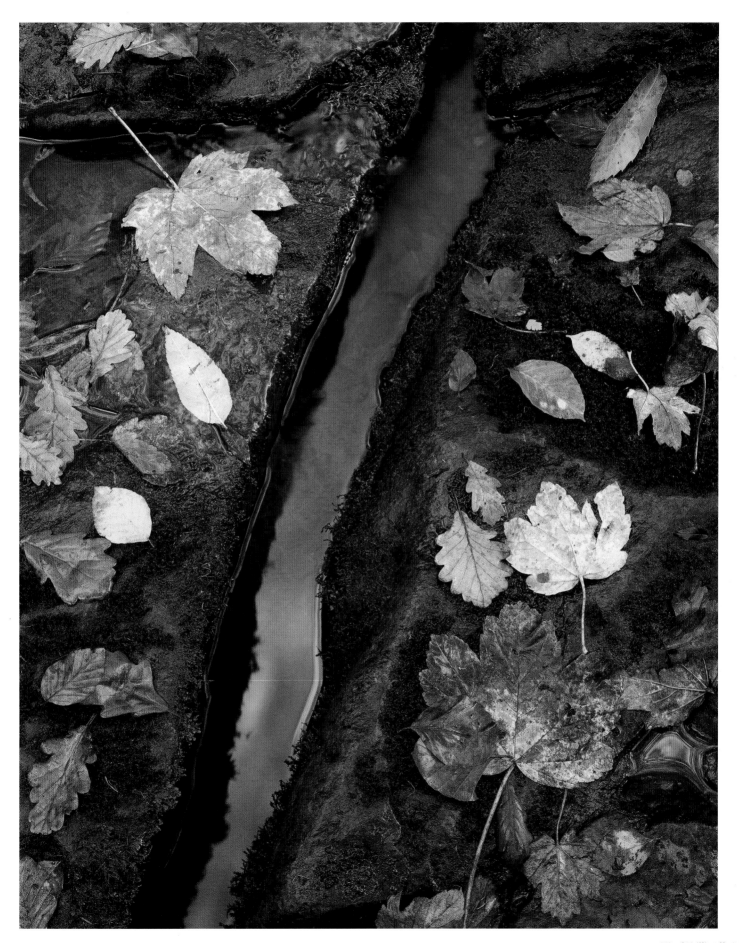

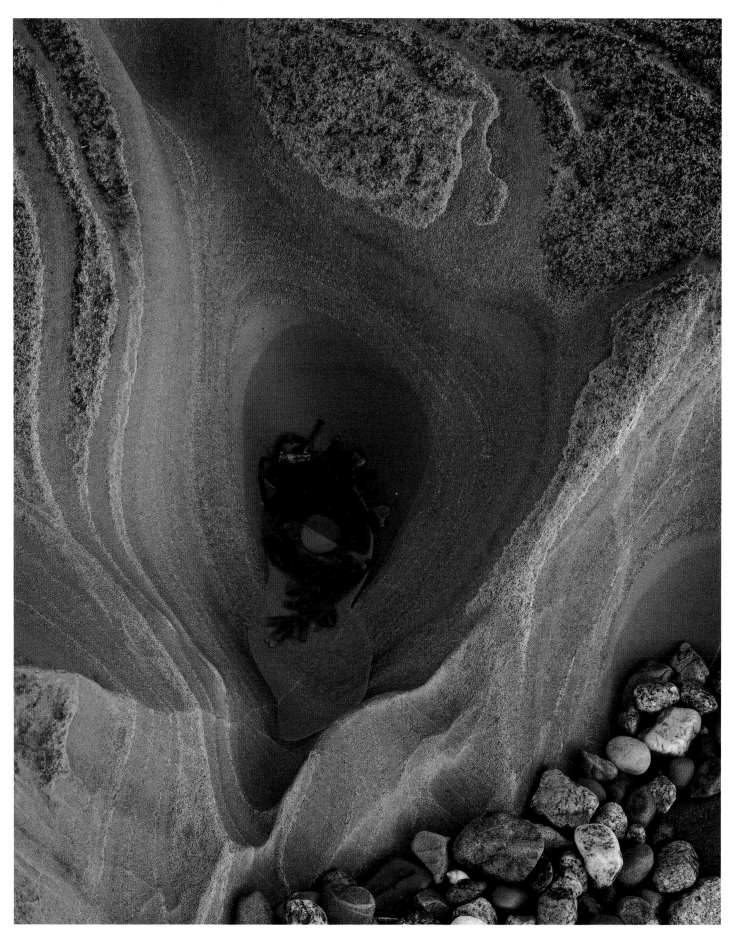

Imacher Point
Nigel Halliwell [p152]

Close-ups are a completely different challenge, which I enjoy. What I look for is the shape and form and the fact that it might be leaf litter or sand patterns is of secondary importance. I also consdier lighting to be more important with close-ups than when shooting landscapes, because the use of warm, cold and reflected light can make or transform the subject. NH

Sandstone rock pool
Nigel Halliwell [p152]

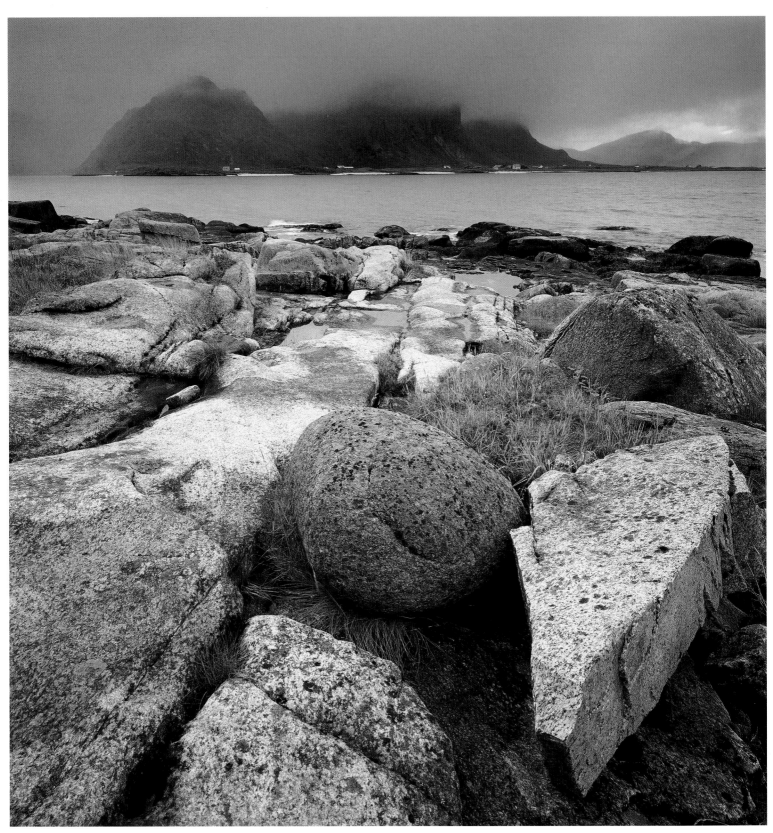

Near Flakstad
Andy Latham [p152]

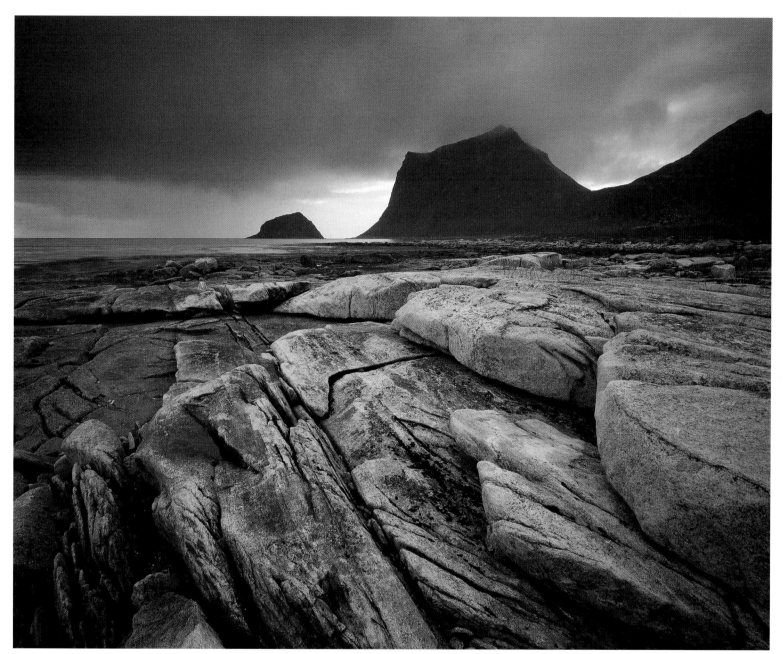

Haukland
Andy Latham [p153]

Andy Latham

I find it difficult to define my own style, or even think of saying that I have one. However I can look at the work of other photographers and say with certainty that my style is not like theirs. I'm sure that the great photographers don't ever consciously consider their 'style' before taking a photograph – it just happens. If pushed, I would say that I hope there is an air of peacefulness about my work. AL

EE: What do you think is the public's view of landscape photography? Has that view changed over recent years?

CW: *We have come a long way from the 'scenic' postcard that has now, paradoxically, become collectable. Generally, the landscape image is most certainly viewed differently now. In the US (perhaps because they have little legacy of landscape painting) much photography has long been recognised as an art form. Recognition of refined landscape photography has been slow to take hold in Europe but, thankfully, over the past thirty years it has become more highly regarded and collectors are now actively engaged in acquiring landscape images.*

Rupert Heath

At the time of making a photograph, thoughts revolve around making the best compromises possible, in terms of composition, a film's limitations and the balance of light. To suggest that I think at all about what an image might convey at the time of its making would be at the very least fallacious. Vision is what we may see in an image itself after its creation, not in its making. RH

I doubt anyone truly 'sees' the final image. Yes, we might come to know exactly what it is going to look like, but not until the image has become a permanent creation, a tangible fact, can we look at it properly, judge and truly see. Only then do we know whether an image has worked or not. Only then does vision arise. RH

'Picasso'
Rupert Heath [p153]

The more fully we are immersed in the experience of the moment, however, the more likely it is that our experience will transfer itself, via some mysterious process, into our images. It is only when this occurs that vision arises, and this is when the viewer may discover a more profound reaction and involvement with an image. This is difficult to write about, of course, as we are dealing with such vague intangibles – experience, vision, emotion and spirit. These things must be allowed to develop of their own accord. Art happens. RH

Perhaps what I am trying to suggest is simply that vision is passion, and that style is a misused term. Vision is really what we're about, and that can be attained through passion and a full understanding of medium and subject matter. It cannot be directly applied, but arises of its own accord when you are true to yourself, and when you are so familiar with your medium that it becomes an extension of yourself. RH

Therefore, a positive intention to impose a distinct style upon your interpretation of the subject may actually stifle it. If you are passionate and enthusiastic about the natural world, your experience of a particular place at a particular time will appear naturally in your work. This is what vision is to me – and if a cohesive vision arises through one's work over time, then this vision becomes one's style. In a sense, they are inherently the same thing. Style is simply a recognisable identifying feature that unifies an artist's work, but this feature is not necessarily compositional or physical (the standard interpretation of style), it can simply be a successful development of the artist's vision. RH

River flow
Rupert Heath [p153]

Andrew Barnes

My style is definitely evolving. I would say that my style is changing as I become more technically proficient and as I become more 'light aware' and discover how I can use ambient light. It's changing as I experiment, grow tired of some aspects of photography and become enthused by new ideas; and as I discover more and more inspiring photographs and photographers who plant the seeds for new projects. AB

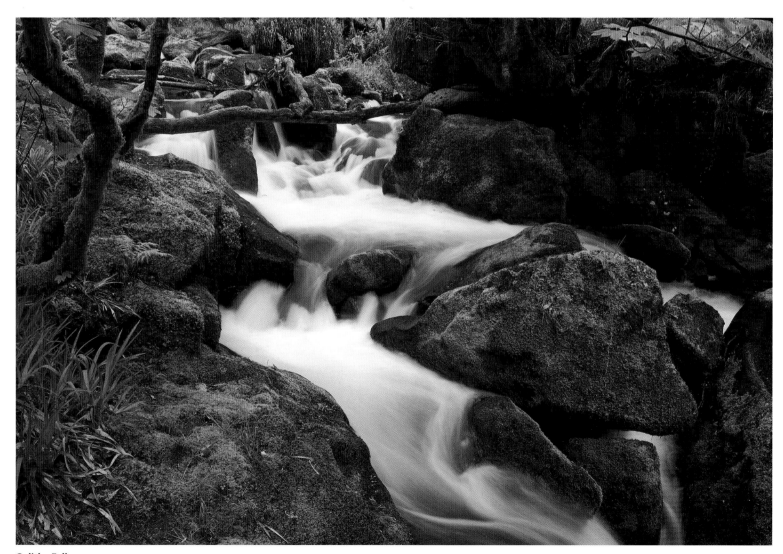

Golitha Falls
Andrew Barnes [p153]

Sunrays, Elvaston Castle
Wayne Brittle [p153]

Wayne Brittle

As I use digital equipment I can review my images immediately, and this means that I can set out to a location with more confidence. WB

River rock pools
Jon Brock [p153]

We can describe a photographer's unique ability to interpret the scene as 'personal vision'. The question is, what constitutes that 'vision'? Is it subject to definition and analysis, or does it defy logic and description? Is it a God-given talent? Can we learn it? JB

Jon Brock

I have become conscious of the importance of striving for some degree of originality and freshness in my images. I believe that understanding how a great image has been made, and using that knowledge to inspire me, adds to (rather than detracts from) my vision. JB

Digital camera equipment, through its LCD screen, dramatically shortens the feedback loop between vision and realised image. It also increases a photographer's ability to achieve a 'print' that more closely resembles their original vision. In this respect, using digital equipment has dramatically improved the opportunity for development of vision. JB

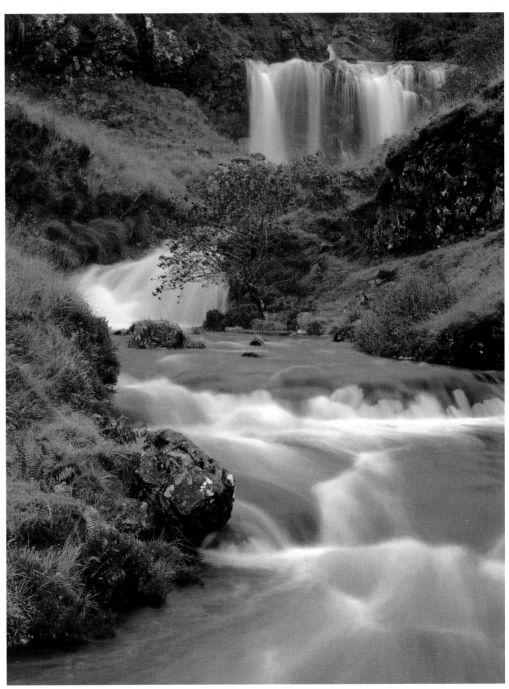

Most of my better images seem to come in a flash of inspiration, an instant when I can suddenly imagine the picture in front of me. Then I move systematically to realise that vision with my camera (with mixed success!). Was the vision really spontaneous, or even magical? To me, vision means the ability of the photographer to 'see' the final image they want to achieve in the imagination. JB

Rowan tree falls
Jon Brock [p153]

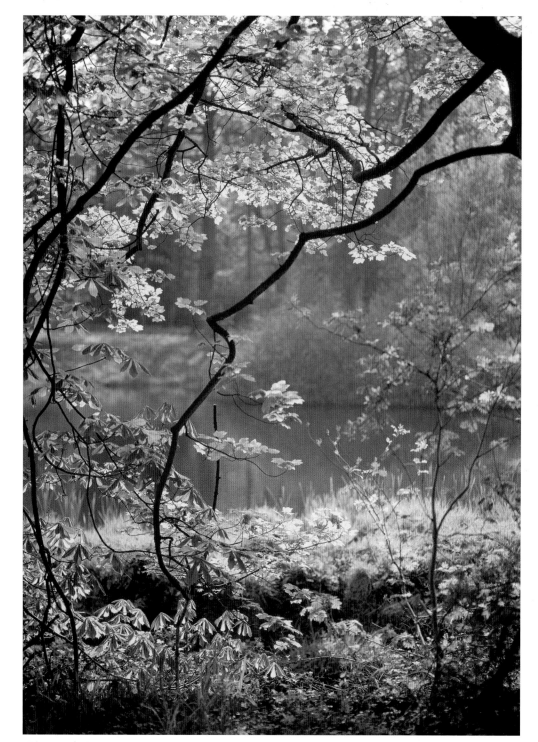

Bliss of solitude
Phil Mann [p153]

Phil Mann

When I moved to medium format, I found that it had a dramatic effect on the way I approached my photography. I slowed down and looked around me more and, as a result, I feel my images became more considered and much better. I would argue this 'slowing down' helped me develop my vision. PM

On the other hand, during my first real excursion with the DSLR, I found that I was experimenting more and making exposures when I might previously have walked away for fear of wasting film. So, I really do feel that I have the best of both worlds now. PM

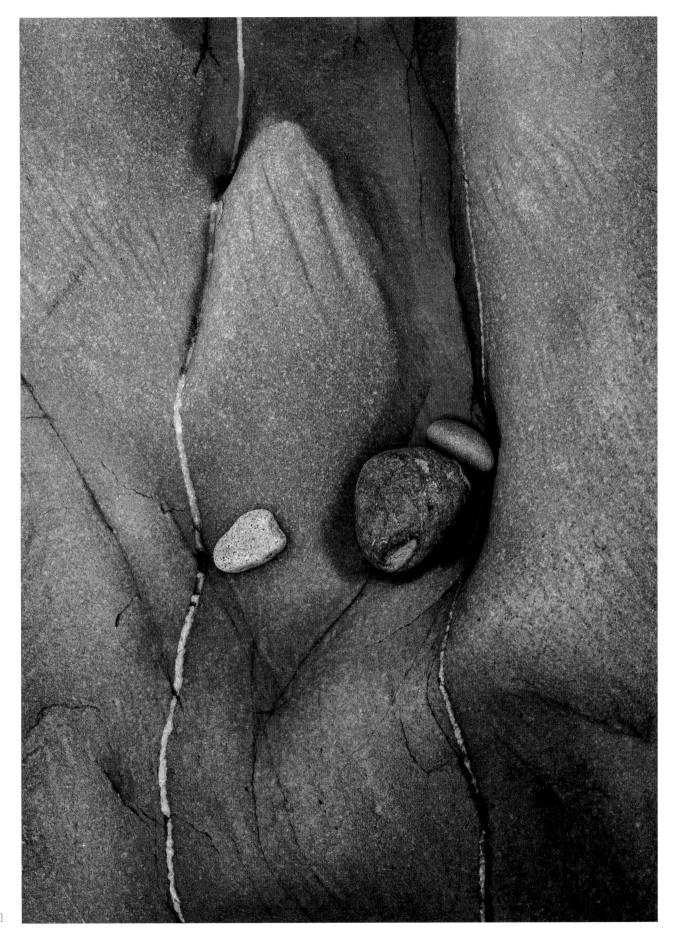

Sculptured
Phil Mann [p153]

EE: Is it best to have just one 'vision' or can we have many 'visions'?

JC: *I am not sure it's 'best' to have any fixed strategy in the creative realm. Your vision is your vision and it may well evolve and change. I remember a wonderful description of the great actor, Laurence Olivier, which was that through the course of his career he never ceased from 'reinventing himself', that he was never afraid to try new and challenging roles, and above all, to take risks. That is probably an indirect answer to the question, but I feel it's an important point to make for all of us seeking to develop our creativity.*

DW: *I think that since our vision is tied directly to how we see and feel about the world we, inevitably, have only one vision. However there may be many facets to this vision which vary according to mood, subject and how far we have travelled in photography.*

CW: *The great masters of painting seemed to have very distinctive visions which we have seen time and again. This is their signature. Photographers will be questioning both their vision and style from time to time through the evolution of their photography. Perhaps there should be periods of restlessness and it may well be that they will fall out of love with some of the images made. The key is to continue to use photography to explore both the immediate world around us and the one within.*

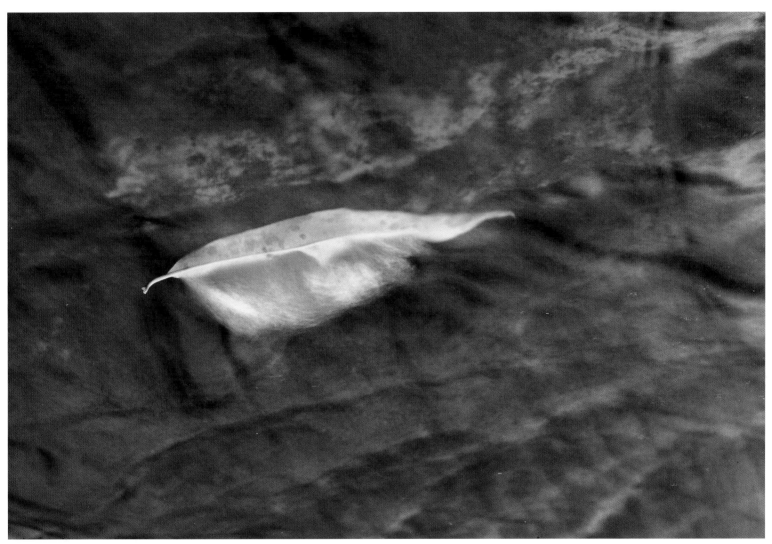

Leaf, emerald pool
Adam Pierzchala [p153]

Adam Pierzchala

I am beginning to think that both vision and style are shaped by early experiences which leave a strong emotional response, which has stuck in our subconscious and guides what we like or dislike. Perhaps it's a photographer's ability to convey his feeling that shows mastery of both vision and style. AP

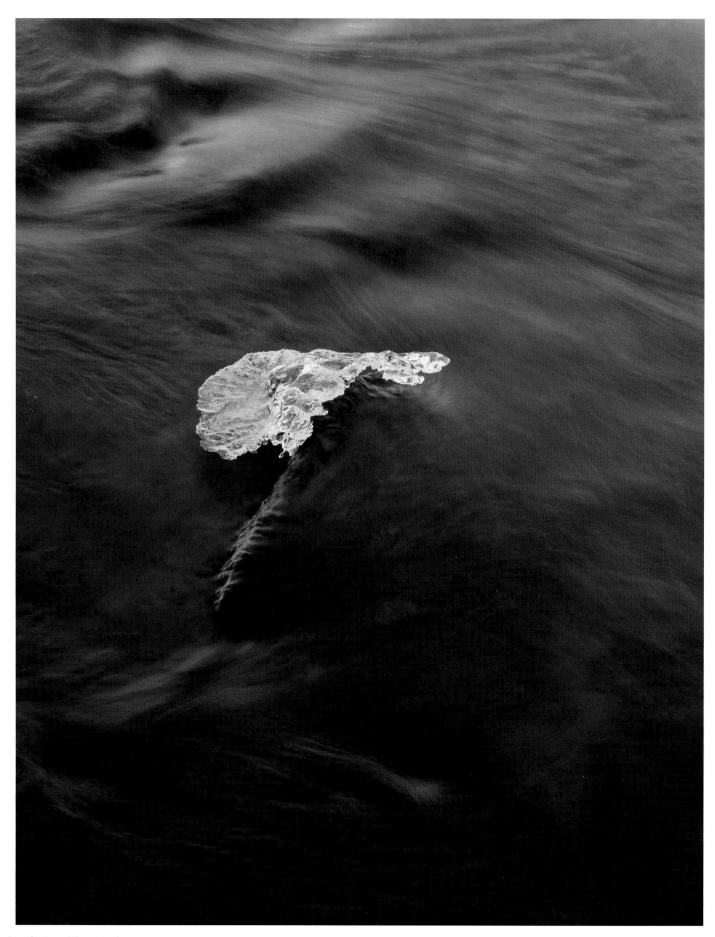

EE: When are you satisfied with your photography?

JC: *Ah, the philosophy of satisfaction, now there's a topic. 'Can't get no, no no no, satis-faction,' – or 'I still haven't found what I am looking for...' If it's good enough for the Rolling Stones and U2, then I'll have a go too! Perhaps the state of photographic satisfaction can be likened to Nirvana, a handy home for yoga gurus, but not really a domicile most of us would recognise. Not me anyway. I am never satisfied. It's not that I am not happy, or fulfilled by what I do. But to be satisfied sounds suspiciously as if you have reached the end of the road, and I see no final destination in sight. A great print, a book, your own gallery even, these things represent signs along the way pointing in the right general direction, as the question puts it, of a commitment to a higher level of achievement. If you were satisfied, what would be the incentive to pursue that higher level?*

CW: *Great, truly great joy is realised during the actual process of making a photograph that I have confidence in and where I have had to tolerate the minimum of compromises. Satisfaction is, surprisingly, a very quiet and very much an inner affair. The finished image in the form of a transparency or print is interestingly revisited at least a week or more after the original exposure has been made. This is very much a comforting and reassuring process; it is made up of further questioning and investigation and, hopefully, ultimate pleasure. The pursuit of higher levels of achievement is certainly bound up with the whole process of my photography.*

DW: *I hope that I'm never completely satisfied with my photography – that will be the day when I give up making images and pursue another addiction. I'm fascinated by my journey through photography and I'm not seeking an ultimate satisfaction beyond an exploration of its possibilities for personal expression.*

Guy Aubertin

In developing my style I am trying to use the natural colours that are around me and not to use filtration. I am learning the 'nature' of Velvia and what it emphasises. I don't subscribe to the view that images need to be effortless to look at; when making pictures of the unusual, you need to engage the viewer. GA

Rock and ice
Guy Aubertin [p154]

EE: Wayne Brittle says he would be happier if his digital shots came out looking like a Velvia transparency. What is it that digital maybe 'lacks'?

CW: *What are the criteria? If, as in my case, the test is ultimately the quality of images on paper then I must make a comparison between, on the one hand, a drum-scanned Velvia transparency and a print made from this and, on the other, a digitally captured file and a print made from that. There are sentimental reasons for photographers not caring for digital capture but others testify to a sterility and soullessness. I have seen images that appear to be 'over sharpened' and in my view this has contributed to digital being somewhat maligned. There are software programs I am told that deliver a 'Velvia' feel to the image. The alternative is to return to Velvia itself, possibly?*

Part of my developing style is to try and be 'quiet' in my image-making. I also, on occasion strive to give the viewer something that requires concentration to understand what is going on. I don't subscribe to the view that images need to be effortless to look at; when making images out of the unusual you need to engage the viewer. GA

Red and white
Guy Aubertin [p154]

Beautiful gatewayw
Quentin Brown [p154]

Quentin Brown

Do I need to have a style? I have the perception that I really ought to. I feel that style can stimulate and inform creativity, with the styles of others giving us inspiration to experiment and our responses to them informing our use of visual language so that we can communicate our vision more effectively. There may be times where we get stuck on style over substance, but these never last since they are ultimately unfulfilling and we will either find we lose interest in the art or rediscover our vision. QB

I think personal style evolves and develops as a means of expressing our vision. This process can take some time and often, as one begins to learn the art of photography, vision itself is placed behind the learning of technique and the adoption of established styles on our list of priorities. This is as much a part of the learning process as it is finding our own way. Later, as this phase passes, personal vision comes to the fore and begins to redirect and hone all we have learned and adopted of style until they reach a point of unity and clarity where our vision is fully and perfectly expressed in our work. This I believe is the final stage in becoming a truly accomplished artist. QB

There are subtler, more unique and individual things which go to make personal styles. These we often develop subconsciously and find very hard to define because they are made up of so many elements coming together. To give them a recognisable name would be making them an established style, otherwise we can name them after another person, like 'Joe Cornish's style' and if others are familiar with their work then they can relate to that. The thing is, this doesn't work either because the style you are trying to describe is unique. I guess in the future if someone asks me what my personal style is and seems to expect a short answer I can say 'Quentin's style'. QB

EE: In what way might our cultural background influence our vision and style?

JC: *This question is not really to be answered in the space of a sentence or two as it is a theme worthy of a whole thesis! Of course, there are endless ways in which our upbringing and our cultural background influence our artistic endeavours, because we cannot make art in a cultural vacuum, and it is appropriate that our work should reflect our core values, our beliefs, our thoughts, and our feelings. Unfortunately, I think that the complexity of the relationship between our cultural background, the tools and materials available at the time, and the prevailing popular culture is such that any description of it is bound to be superficial. Ultimately, the content of our individual minds and intentions remains a mystery, and inexplicable, even to ourselves. Why do I do what I do? Sometimes I think I know, then I realise I don't really, and no amount of explanation or justification matters. I just do it. And I would guess that many others feel the same. You could call it ego, or love, or destiny, or religion. You could even call it art.*

Nick McLaren

Some people are simply more visually aware and observant of their surroundings than others. They see shapes in a shadow, a cloud, a rock or sand that we would compare with objects we see every day, or they might simply be attracted to their subjects' patterns and structure. I believe possessing that kind of heightened awareness greatly increases our chances of successful landscape photography. A composition can suddenly appear within a step, and vanish in the next. We need to be poised, ready to seize that moment in our minds, whereas another person may pass it by without a thought. NMcL

There are many photographers with many different styles, but not all are individual. They can be grouped into categories such as 'abstract' or 'realistic', but for me the photographers who can truly be said to possess an individual style are landscape pioneers such as Ansel Adams and Minor White, as well as photojournalists such as Robert Capa and Henri Cartier-Bresson. We have all followed with our own subjective interpretations, but in most cases there will always be a trace of their vision or style inherent in every image we make. NMcL

Sea of barley
Nick McLaren [p154]

Moss on wall
Colby Chester [p154]

Silence and light
Colby Chester [p154]

Colby Chester

Vision refers to what we see. A cultural extension incorporates the aesthetics of our philosophy or world view into this concept, as in the 'vision' of a leader, mentor or corporate executive. By this standard, my vision as a photographer is limited by my physical ability to see and by the restrictions I choose to place on my field of view as a result of my education, both formal and spontaneous. While I am not consciously intent on revealing my vision when I am taking photographs, my work seems to conform to a standard expressed in the framing and resolution of a particular subject. This standard has been greatly influenced by the work of other photographers, both renowned and obscure, whose images have become imbedded in my interior gallery. CC

EE: When and why are you surprised by your own photographs and by that of others?

JC: *I am surprised by mine most usually at the lab. Usually it's a bit of a mixed bag of disappointments and pleasant surprises. Obviously it's nice to have more of the latter than the former. After a recent trip to Scotland I had just one decent transparency from 40 sheets of film. That was pretty heart-breaking, however mentally tough you are.*

Christos Andronis

In my mind, the word 'vision' is synonymous with achieving a goal and it includes the means or the path leading to this goal. As far as my photography is concerned, I would describe vision as a place to be, a destination, not in terms of a physical location but mostly as a state of mind. In this respect, my vision in approaching landscape photography is to create images that convey a sense of balance, inner peace and sometimes solitude. CA

How would I describe my style? I use anything that could potentially convey a sense of balance, usually trying to keep my compositions simple and allowing one or two elements to dominate. Style should never overwhelm an image. My subject matter dictates the way I approach my photographs. Although, like most landscape photographers, I feel very connected with vast open spaces, the lack of such spaces in modern Greece has turned me towards the smaller scale, the inner landscapes. CA

Red rocks
Christos Andronis [p154]

EE: How would you describe your vision and style in relation to Charlie and David?

JC: *When we wrote* Working the Light, *the three of us almost spontaneously (actually it was probably Eddie's idea) came up with the broad categories of landscape we felt we could represent. Charlie? Inhabited landscape. David? Intimate landscape. Me? Wild landscape. There is an obvious distinction here, in that each of us tends to feel more at home dealing with these broad categories, although we also all venture into each others' areas frequently!*

Stylistically, Charlie's work is still associated very closely with the square format, although he has also made marvellous images in panoramic. But the square has been decisive in defining the design, rhythm and orderliness that characterise his most famous compositions. Like all great photographers, lighting quality is a hallmark, but then so is strong colour. As I have been so influenced by his work over the years I cannot really say more than this, but I know when you look at our pictures you can tell the difference! In fact it was not until I stopped trying to be like Charlie that I really gave myself the chance to develop my own vision.

With David it is more complicated as we both shoot large format, and we both like similar subject matter, albeit his focus is more frequently close to the camera. And yet in some ways it is easier to define the differences. David's pictures, his close-ups anyway, are like self-contained worlds. My close-ups are usually referential to what lies outside the frame. David exploits ambiguity of scale as a primary tactic, creating mystery and intrigue. His pictures ask questions, forcing the viewer to engage their brain. By comparison, my stuff is fairly literal and pretty obvious (I think I suffer from what David calls 'early closure')! When it comes to 'vistas' (as David ever-so-slightly perjoratively refers to them) his compositions seem more compact than mine, and typically are perhaps somewhat darker in mood. I would be flattered to have my work confused with his, but in practice this never happens!

Pwll-y-Wrach Waterfall
Steve Gray [p154]

Steve Gray

As one gains experience and knowledge, it is easy to become accustomed to a particular way of working (and a particular set of photographic tools). This will inevitably lead to a similarity in style in those images that are taken without an awareness of where new opportunities might lie. Conversely, you could argue that being confident about your own style and working practices creates a reliable framework within which creativity and vision can flourish, as you see different compositions and utilise new techniques safe in the knowledge there is a solid photographic bedrock on which to build. SG

VISION & STYLE NOTES

Encapsulating a photographer's vision and style in just a few hundred words is always going to be an impossible task. The depth of information in an image which is not translatable into a written language – which is actually beyond words – is immense. This ineffable text is the photographer's real language and it alone can convey the subtleties that truly define their vision. A written analysis can only be a partial explanation and, at best, offer an intrinsically biased opinion. David Ward

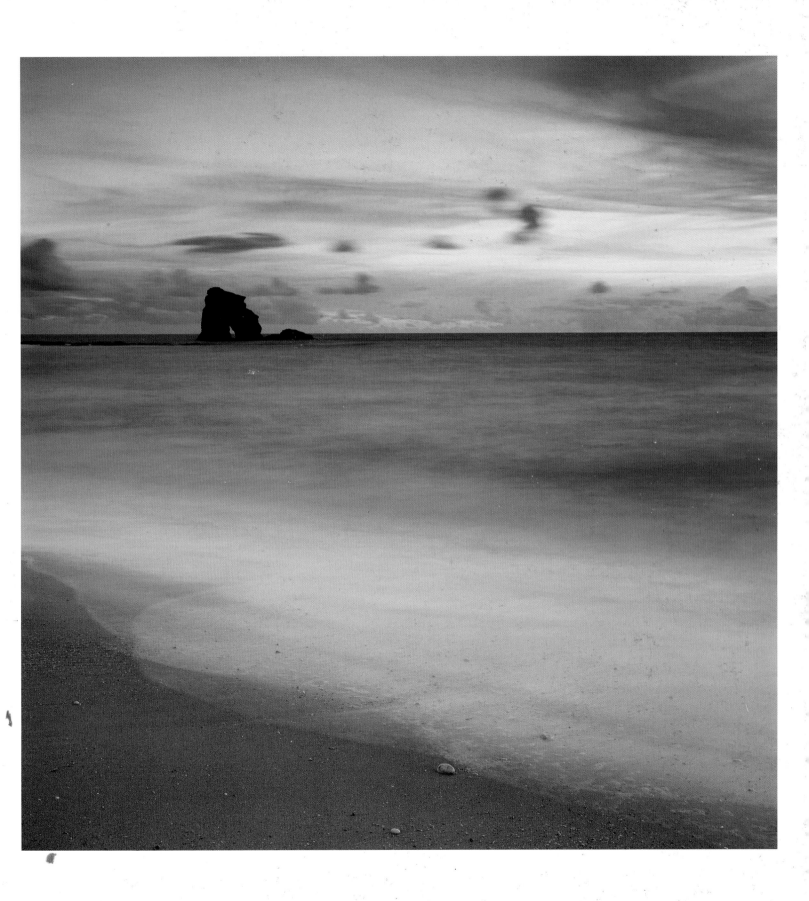

[p13]

[p15]

[p16]

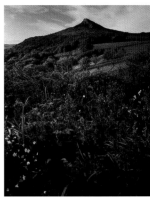

[p19]

Charlie Waite on Joe Cornish

Many of Joe's images seem at first sight to amount to revelations. It is as if he is privy to a world that looks far more ravishing than the one that the rest of us live in and shows us places that surely cannot really exist – but, of course, they do. There is a grandeur to his work that compels us to revere both his expertise and the essence of the places he portrays

His great achievement is that, through his vision, his art and his astonishing photographic dexterity, he is able to take us, in one huge leap, into the very heart of a place that he has identified as being wondrous. His personal standards are stratospherically high and his desire to convey every nuance and detail of what lies before him matters greatly and contributes greatly to the pleasure we get from viewing his work.

Here is work by a craftsman of the highest calibre. Although it seems to me that craftsmanship is a quality that some in the world of fine-art photography are astonishingly unconcerned with.

Landscape photography can very easily be impoverished by the two-dimensional nature of the finished work. In many of Joe's images he contrives to mitigate this problem and to convey a three-dimensional, tangible quality. Looking at these images we feel ourselves captivated, mesmerised and transported to a world that, Joe wants to remind us, lies right at the heart of our human experience.

David Ward on Joe Cornish

Joe's chosen landscapes would best be described as wild, even if often not strictly wilderness, because the hand of man is not readily apparent. He favours the vista, despite making excellent detail studies, and the most obvious stylistic feature of his work is the progression from strong foreground object, through middle ground to a distant, wide view. The solid geography of the coast or mountains particularly lends itself to his approach. Joe leads the viewers' eyes on a journey through the scene without them realising that they are being subtly, but insistently, directed. Like that of any adept, his work seems effortless.

He prefers dramatic, transitory light and whereas for me the window of opportunity for a photograph may be quite large, minutes or hours, for Joe it often really is a decisive moment – a matter of seconds or fractions of a second. Just as the work of man is seldom evident in his landscapes, so Joe's own presence is barely visible in his images. He works hard at making his compositions and his use of filtration seems naturalistic. His photographs mostly eschew ambiguity: he prefers to represent the world in a seemingly straightforward way. The depiction of fine detail is important to him and, perhaps as a result of his early work in black and white, he abhors deep, featureless shadows in his images. The resulting images are complex but balanced and self-contained and their tone is celebratory.

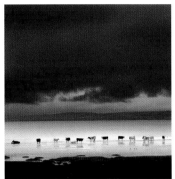

[p57]

[p58]

[p60]]

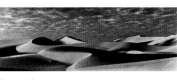

[p62-63]

Joe Cornish on Charlie Waite

Charlie has been a prolific book photographer, and a pioneer of modern colour landscape photography. Looking at some of his earlier work from the 1980s I am struck by how right these pictures still look now, even though the reproduction quality of the time does scant justice to his work. If there is one quality that stands out the most it is his ability to apprehend the essence of the landscape. He has always had the ability to sum up the scene, pare it to its essentials, and compose it elegantly, however helpful or otherwise the light.

I know from my own experiences doing books that the ability to make a picture work, sometimes in spite of the light rather than because of it, is an enormous asset for a hard-working photographer. Moreover, Charlie's sense of composition has always been unerring. He has made pictures of architecture, of street scenes, of people, and of nature's details over the years, but I always feel he is at his best looking out over a landscape in southern Tuscany, or on the Cotswolds fringes, or in the Dordogne, over landscapes where the handiwork of man and the rhythms of the landscape become one. His empathy for these places, his deep love of traditional agricultural countryside and his uncanny ability to use light that reveals the cadences of the landscape allows him to create a distillation of the subject. His work is often mistaken for, and compared to, painting, and it is not hard to see why.

David Ward on Charlie Waite

I feel more aware of Charlie's presence in his images than I do of Joe's in his. This isn't because the compositions appear contrived, but rather because Charlie's vision is more unusual and hence makes itself more apparent. His early 6X6 images, in particular, exhibited striking and unusual compositions. The images often have a deep formal structure. He likes to use symmetry in general, such as the rhythm of a tree plantation, and to play with architectural forms, but he particularly likes the juxtaposition of rectilinear and natural forms.

Unlike Joe, Charlie is more concerned about the custodial relationship between the farmer and the natural world, concentrating on the patterns of agriculture and the structures of man within the landscape, providing these fit within a romantic, agrarian mould. Like me, Charlie frequently works in soft light. The tone of his images is more contemplative than exclamatory. He extracts subtle pattern and meaning from seemingly unpromising subject matter.

I feel that there is essentially a contradiction at the heart of Charlie's landscape photographs. The viewer is presented with the landscape as a tableau; a depiction with a limited sense of depth – his images rarely contain the classic 'S' or 'Z' device – but this lack is accompanied by a rich and compelling characterisation. Yet this depthless quality never means that they are shallow. The photographs enthrall without exclamation.

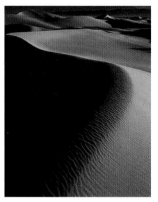
[p100]

[p101]

[p103]

[p105]

Charlie Waite on David Ward

In his very profound and immensely articulate book on landscape photography, David helps us to better understand how we respond emotionally to a potential image and what may be taking place in our deep subconscious as we contemplate it. David is deeply and acutely absorbed with the whole notion of perception.

But despite his exceptional ability to use the written word to delve deep into motivation and inspiration, and indeed style and vision, his photography can speak for itself. No intellectual explanation or validation should ever be needed to support a landscape image and none will ever be needed for David's work.

His intimate and deeply personal 'near to the eye' landscape photography reveals a brilliant ability to juxtapose shape, form and colour, bringing them all together into a beautifully cohesive and balanced design.

David's passion for the natural world around him is evident time after time in his landscape work; it is clear that the study of the surface textures of rock or wood can preoccupy him for many hours. His astonishing photographic artistry introduces us to a series of wondrous worlds that we might trip over in passing had he not encouraged us to stop, look and truly see.

Joe Cornish on David Ward

When David shows me his latest transparencies, usually after a recent trip, I know I will be in for a mixture of emotions. The downside is the envy, partly for the places he has seen, but mostly at his prodigious gift for visualising the world in ways I could never imagine! However, mostly I am just thrilled to see such amazing images.

I believe that David is ahead of his time, that the pictures he makes cannot be easily understood or appreciated by all, but that eventually what he does will be recognised as some of the best photographic art of this or any other time. His striking close-ups deal in mysteries, in ambiguities, in unlikely juxtapositions. He is able to see the universe, if not in a grain of sand, then at least in a rock detail. He seeks transcendence, in images that are more than the sum of their parts, and he frequently succeeds in his quest. The enigmatic natural worlds which he discovers are often no more than a couple of feet square – a weathered wooden post, or a cluster of shells, or some wet rock with coloured reflections, or some pale sand with a pebble or two. Yet he invests these humble surfaces with a meaning and significance out of all proportion to their perceived value. In so doing he forces us to question our assumptions about perception and about the place of things in the cosmos. Not bad for a landscape photographer! And not a pixel in sight.

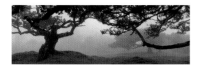

LAURELS IN THE MIST [p4-5]
Peter Karry
Location: Lagoa do Fanal, Madeira.
Camerawork: Hasselblad XPan, 45mm, 1/4 second at f16, centre spot filter, Fujifilm Provia 100.
Technique: This photo was taken as the mist was rolling in from the sea. I liked the way that the approaching mist caused the colours in the image to diffuse, creating a feeling of depth through the separation of the planes. I waited for the sun to break through, but when it did, the mist dispersed and the atmosphere was lost.

SWIRLING LEAVES [p7]
Mark Sunderland
Location: Strid Wood, Yorkshire, England.
Camerawork: Canon EOS 5D, 24-105mm lens at 40mm, 8 seconds at f22, ISO 100.
Inspiration: I was walking by the River Wharfe in Strid Wood on a damp autumn day, and the movement of these fallen leaves in the river caught my eye. The long exposure traced their path through the water perfectly. I have to say that this image fascinates me, as it is somehow simple and complex at the same time. The colours of the leaves under soft, diffused light are a very important part and I just like it because of the three layers of colour. But here movement plays a more important part in creating an abstract effect.
Style: All detail in the water is lost and the complexity of the eddies in the river is revealed. This was one of the first landscape images I made digitally and, although I set the shot up with care and precision (which comes naturally after using 5x4 equipment for six years), the new medium allows a greater degree of experimentation. I think this is good news for anyone seeking to make creative landscape images.

VITALETA [p9]
Angela Baldwin
Location: Tuscany, Italy.
Camerawork: Canon EOS 20D, EF 70-200mm f4L at 81mm, 1/125 second at f11, no filtration, basic RAW processing, cropping and sharpening.
Inspiration: The Vitaleta chapel stands on a hill alongside some farm buildings. Late one May afternoon, the sun lightened the white stonework of the chapel, contrasting with the surrounding hills and green foreground. What completes the picture, however, is the light on the cloud formation above. This adds interest and a sense of mood, without which this would be an ordinary landscape view.

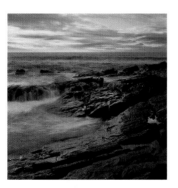

SANDWOOD BAY [p21]
Tamara Kuzminski
Location: Sutherland, Scotland.
Camerawork: Hasselblad 503CW, 80mm lens, shutter speed not recorded, f22, Fujifilm Velvia 50, 2-stop ND grad and 81C filters.
Inspiration: Sandwood Bay is a wide, sweeping beach of golden sand. However, as the sun was setting, waves from the incoming tide were crashing over a rocky outcrop in the middle of the beach. It was quite difficult to find a composition with which I was happy, as every couple of waves forced me to grab my camera and quickly retreat for fear that it would get a soaking.

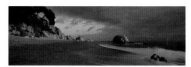

SPANISH BEACH [p22-23]
Nigel Baker
Location: Costa Brava, Spain.
Camerawork: Fuji 6x17 Panoramic, Fujifilm Velvia 50.
Technique: Taken in very transient light, it only lasted a matter of minutes. I had to set up quickly. I think it was the quality of light which inspired the image.

SCALEBER FORCE [p24-25]
Nigel Baker
Location: Scaleber Force, Near Settle, North Yorkshire, England.
Camerawork: Fuji 6x17 Panoramic, Fujifilm Velvia 50.
Inspiration: I love the movement of the waterfall compared to the very static tree trunk on the far bank. It was taken in overcast lighting.

YORKSHIRE TREE [p24-25]
Nigel Baker
Location: Twistleton Scar, North Yorkshire, England.
Camerawork: Fuji 6x17 panoramic, Fujifilm Velvia 50.
Inspiration: Again I was drawn to the transient nature of the light. The foreground tree gives depth and conveys wind movement over time.

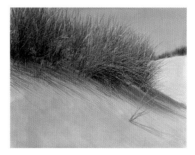

DUNE AND MARRAM GRASSES [p26]
Paul Gallagher
Location: Formby Point, Merseyside, England.
Camerawork: Walker Titan XL 5x4, 150mm Schneider lens, 1/30 second at f11, Ilford Delta 100, yellow Lee filter.
Inspiration: While walking through the dune system in Formby, one is overwhelmed by the size of the area and sound of the sea. I sat down on a dune in the strong warm sun, sheltered from the wind and was confronted with this beautiful undisturbed area of sand and marram grasses with new shoots reaching from beneath. The light was spectacular and bright, but all the tones were subtle. I wanted to convey the delicate detail of the large and small marram grasses along with the brightness of the sun on the pale sand. I can still feel the warmth of the day when I look at this image

PINE PLANTATION [p27]
Paul Gallagher
Location: Borders, Scotland.
Camerawork: Walker Titan XL 5x4, 90mm Schneider Lens, 1.5 minutes at f22, Ilford Delta 100, uniform ND filter.
Inspiration: This was a lonely and eerie place which presented to me an almost duo-culture of pine trees and white forest-floor grasses. I was captivated by the stillness of the trees as the grasses swayed and danced at their feet, producing an exquisite sound. I wanted to convey this sound in the image and show the fine detail of the bark in the stillness of the trees.

SKIPNESS BEACH [p28]
Paul Gallagher
Location: Argyll, Scotland.
Camerawork: Walker Titan XL 5x4, 90mm Schneider Lens, 2 minutes at f32, Ilford Delta 100, uniform ND filter.
Inspiration: This remote and little visited area of Argyll offers unusual geological coastal structures that produce small rocky inlets. The weather was heavy and still, and the rocky outcrops on the edge of the Kilbrannan Sound wet and black. Between them, I caught glimpses of Arran. I was left only with the movement of the water surging through the gap during each swell which pushed and pulled the shale on the beach. It was this movement, which is the vital component of the composition, that motivated me to make the image.

BUACHAILLE ETIVE MOR AND RIVER ETIVE [p29]
Paul Gallagher
Location: Scotland.
Camerawork: Walker Titan XL 5x4, 90mm Schneider Lens, 1 second at f22, Ilford Delta 100, light red Lee filter.
Inspiration: This iconic Munro was veiled in cloud which was slowly clearing. I wanted to convey its scale on the edge of Rannoch Moor. Faced with this mountain you cannot help but feel small and somewhat insignificant when you look up towards its summit. The cascading river and wind-blown trees are indicative of this dynamic and rugged environment.

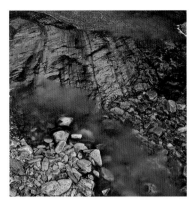

ENCROACHING ICE [p30]
Adrian Hollister
Location: Inverness-shire, Scotland.
Camerawork: Canon EOS 20D, 6 seconds at f22, ISO 100.
Inspiration: This somewhat abstract image shows where the ice has formed on either side of a river, leaving a gap in the middle through which the colour of the rocks and stones are seen enhanced by the water and early morning light.

FOREST AT SUNRISE [p31]
Adrian Hollister
Location: Berkshire, England.
Camerawork: Canon EOS 5D, 1/45 second at f22, ISO 1000 (yes, 1000!).
Post-capture: This image of the early morning sun lighting up part of the forest has, in my view, benefited from a touch of de-focusing. I have introduced Gaussian blur to a layer and reduced its opacity to allow the original sharpened image to show through. This is the furthest I would normally go in changing an image in Photoshop. (I say changing as opposed to basic editing of levels/curves in Capture One LE, sharpening with Focal Blade plug-in and saturation using Velvia Vision plug-in). Why shouldn't I use a Velvia plug-in when film photographers get the same effect using Fujifilm Velvia 50?!

AUTUMN GLORY [p32]
James Michael Cox
Location: Padley Gorge, Peak District, England.

Camerawork: Canon EOS 10D, Sigma 17-35mm, 4.5 seconds at f22, ISO 100, no filters.
Post-capture: Levels in Photoshop.

BLISS POND [p35]
Chris Andrews
Location: Vermont, New England, USA.
Camerawork: Linhof Technikardan 45S, 300mm lens (rear tilt), 1 second at f32, Fujifilm Provia 100F, Lee 0.45 ND filter over sky area, Gitzo tripod and Manfrotto 410 head.
Post-capture: Scanned into Photoshop Elements using an Epson Perfection V700 flatbed scanner with no further post-processing.

THE APOSTLE [p36]
Michael James Brown
Location: Gibson's Beach, Great Ocean Road, Victoria, Australia.
Camerawork: Fuji GX617, 90mm lens, 0.6 Neutral Density grad, Fujifilm Velvia 100.
Inspiration: These moments are what photographers live for. It's a feeling of ecstasy mixed with trepidation about getting the metering correct. My first thoughts, strangely, were about flare, so I positioned myself in the shadow of the Apostle and took what seemed to be hundreds of spot meter readings to get a feel for the difference in light levels, which was obviously vast. I waited for a wave to cover the sand in the foreground, and then waited long enough for the water to retreat. I took the picture when the surface water had seeped through to that magical point where the wet sand becomes a mirror and reflects the highest level of light.

REEDS ON LOCH LURGAINN [p37]
Ross Brown
Location: Inverpolly, Scotland.
Camerawork: Pentax 67II, 55mm lens, f22, Fujifilm Velvia 50 rated at ISO 40, 0.6ND hard grad filter.
Inspiration: This was my first trip to this location – a beautiful quiet inlet on Loch Lurgainn, with a distant view of Stac Pollaidh. I wanted to emphasise the beautiful serenity of the reeds on the loch, compared to the dramatic early morning sky.
Technique: I framed the loch so it lead from the bottom left corner of the picture, and wanted to emphasise and separate the island with the tree from the edge of the frame. The clearing of the sky above Stac Pollaidh helps lead the eye towards the mountain.

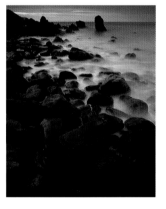

PORLOCK BAY [p38]
Sean Lewis
Location: Somerset, England.
Camerawork: Pentax 67, 55mm lens, 1 minute at f22, Fujifilm Velvia 50, polariser, 81C and 0.9 ND grad filters.
Inspiration: This was my second visit to this location. I was totally absorbed in my surroundings and I tried to capture the pure joy of the experience in this magical place.
Technique: I used an 81C filter and a long exposure for the waves.

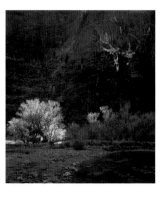

ZION LIGHT [p40]
Julian Barkway
Location: The Big Bend, Zion Canyon National Park, Utah, USA.
Camerawork: Ebony 5x4, 150mm lens, Fujifilm Velvia 100, no filters.
Inspiration: I originally wanted to capture the sunlight highlighting just one isolated tree. However, by the time I had focused my view camera, the sunlight had moved. My original (and superior) composition could not be realised but, fortunately, I was able to move and re-focus the camera quickly as the sun then settled on this small stand of cottonwoods. Not bad for second best, I feel.

MAY BECK [p41]
Julian Barkway
Location: May Beck, North Yorkshire, England.
Camerawork: Ebony 5x4, 150mm lens, no filters, Fujifilm Velvia 50
Inspiration: I was attracted firstly to the small, trapped leaves below the surface of the water. However, as I looked closer, I saw the interesting reflections of foliage and sky and how this interacted with the brown ironstone of the riverbed. Fujifilm Velvia 50 came into its own in the overcast conditions, making the most of the subtle colours. The one thing I am less sure about is the composition; it nearly works but there's something missing. I still wonder how I could have improved this aspect of the image.

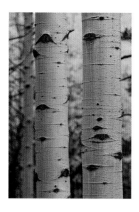

ASPENS [p42]
Janneke Kroes
Location: Rocky Mountains, Canada.
Camerawork: Nikon D70, 150 mm lens, no filtration.
Inspiration: I was attracted by the texture of the bark against the yellow backdrop created by the out-of-focus foliage.
Post-capture: Contrast adjusted in Photoshop.

ANGEL GLACIER [p43]
Janneke Kroes
Location: Iceland.
Camerawork: Nikon D70, 150 mm lens, no filtration.
Inspiration: I was attracted by the colours of the glacier and the sense of serenity created by the stillness of the (frozen) water, which was in contrast with the impressive surroundings.
Post-capture: Contrast adjusted in Photoshop.

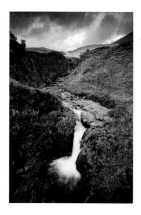

ALLT A CHOIRE GHREADAIDH [p44]
Paul Marsch
Location: Glenbrittle, Isle of Skye, Scotland.
Camerawork: Canon EOS 5D, EF16-35mm lens at 26mm, 1/3 second at f22, ISO 400, 0.6 Lee ND grad.
Inspiration: I discovered this amazing valley by accident when scouting around during my trip to Skye. The mid-afternoon weather was patchy cloud with the occasional burst of sunshine breaking through. It was also very windy, hence the

high ISO setting. I thought that the scene, with the double dogleg river, the waterfall and red berries was just magical.
Technique: I set up shop and after a long wait the sun did finally break through. Unfortunately it had moved too far around to illuminate the heather-covered left-hand bank and instead the light fell on the distant hillside – a nice consolation prize. I made a note to return about a month earlier next year when the heather will be in full flower.
Post-capture: RAW conversion in Rawshooter, boosted contrast in CS2.

ELGOL EVENING [p45]
Paul Marsch
Location: Isle of Skye, Scotland.
Camerawork: Canon EOS 5D, EF24-70mm lens at 24mm, 3 seconds at f22, ISO 50, 3-stop Lee ND grad, polariser.
Inspiration: I had planned the trip to Elgol but, having underestimated the journey time, I arrived as the sun was approaching the horizon. I was immediately struck by the rock formations and the colour of the place.
Technique: I wanted the foreground fissure to lead the eye through the image towards the Cuillin Hills in the distance without itself becoming the focus of the image – hence the offset. I also wanted to pick up the reflection of the sky in the mid-ground sea.
Post-capture: RAW conversion in Rawshooter, CS2 curves and mild shadow recovery.

CLOUD & TREE [p46]
Richard Holroyd
Location: Ivinghoe Beacon, Buckinghamshire, England.
Camerawork: Ebony SW, 150mm lens, 1 second at f22.5, Fujifilm Velvia 50, Lee polariser, 0.6ND, 0.3ND and 81B filter combination.
Inspiration: The cloud was a 'wow' moment. It was evaporating before my eyes as I ran, with a 20kg backpack on a hot day, until I had a viewpoint with the counterpoint of the stunted Hawthorn tree on the horizon. Within a minute, the cloud had gone.
Post-capture: Levels, colour balance and cropping.

BEACH BALLS [p47]
Richard Holroyd
Location: Robin Hood's Bay, North Yorkshire, England.
Camerawork: Ebony SW, Lens 150mm lens, 8 seconds at f32, Fujifilm Velvia 50, 81B filter to allow for long exposure.
Inspiration: I noticed the shapes of the two boulders, the contrasting textures and felt that, together with the sand, they showed the natural, inevitable and beautiful process of erosion. I think I could have only created this image with a large-format camera.
Post-capture: Levels, colour balance and cropping.

KNOCKANES AND LOUGH GEALAIN [p48-49]
Hazel Coffey
Location: near Mullaghmore, The Burren, Co Clare, Ireland.
Camerawork: Canon EOS 5D, Canon EF 24-105mm lens at 58mm, 1/6 second at f22 (underexposed by 1/3 stop), 0.6ND grad filter.
Technique: This photograph was taken at sunset on a freezing November day. The west-facing hill was suffused with shades of red from tawny to fiery as the sun was reflected on the bare rock and bare hazel scrub. The sky and lake were, by contrast, tinged a delicate pale pink. The colouring was almost surreal. The sky had no content but its colour, and the lake shore had no beguiling rocks in the water. Therefore I cropped severely to make it an image all about infused sunset colour on a Burren landscape.
Post-capture: Levels adjusted in Photoshop.

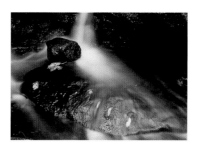

HAY WOOD [p50]
Michéla Griffiths
Location: Derbyshire, England.
Camerawork: Minolta Dynax 5, 28-80mm lens at 60mm, 8 seconds at f11, Fujifilm Velvia 50, polarising filter, tripod.
Technique: Sometimes the best compositions can be the last ones to be

found. I was on my way back to the car, walking up the side of one of the many streams in Hay Wood when I came across a small waterfall. I gradually recomposed the scene, from general views to closer shots. I focused on this small stone perched on a larger rock, and the autumn leaf trapped below. At one point in the sequence, a furry nose appeared between my legs as I concentrated on the composition, with my tripod half in the stream. Fortunately I did not jump too much, so neither my camera nor I ended up in the water. The passing walkers, with their inquisitive dog, said that it wasn't quite Niagara Falls. Beauty, as they say, is in the eye of the beholder.

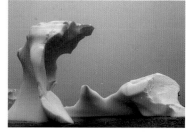

ANTARCTIC ICEBERG [p51]
Pat Douglas
Camerawork: Canon EOS5D, 70-200mm f4 L lens, 1/320 second at f11, ISO 320.
Inspiration: Antarctica is a landscape so hostile that is shaped by nature alone. Now the whole Antarctic environment is under threat: the threat of global climate change caused by human activities. The balance of humankind versus Antarctica is shifting and both humankind and Antarctica will be the losers. As the global temperature increases, the iconic Antarctic landscape will disappear. Only the photographs will remain.
Post-capture: Altering levels in Photoshop and conversion from RAW to Tiff formats.

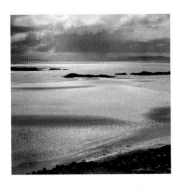

KILDONAN BAY [p53]
Frans R. van Wilgen
Location: Isle of Eigg, Scotland.
Camerawork: Canon EOS 20D, Canon EFS 17-85mm IS USM lens, 1/80 second at f11, ISO 100.
Inspiration: One of my 'lucky' shots, in terms of how it turned out in print. I was attracted by the view and, in particular, by the lighting conditions. The sky contrasts with the dark area of land in the middle distance. I feel the foreground is essential to the general atmosphere and composition.
Post-capture: Some work in Adobe Photoshop CS2.

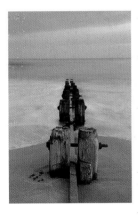

GROYNES [p65}
Nadia Isakova
Location: Alnmouth Beach, Northumberland, England.
Camerawork: Nikon D200, Nikon 18-200mm lens.
Inspiration: I just loved the moody sky, the slow movement of waves and the soft light on the wooden groynes receding into the water. A reasonably small aperture has kept everything sharp, but avoiding too much blur in the water.

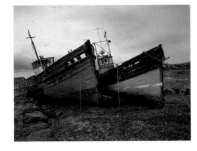

OLD FRIENDS [p66]
Mel Foster
Location: Mull, Scotland.
Camerawork: Ebony 45S, 1/2 second at f22, Fujifilm Velvia 50, 0.45 hard ND filter.
Inspiration: Old friends who've weathered the storm, giving mutual comfort.
Technique: I worked hard at the composition to nestle the boats together while still keeping their outlines distinct from one another. I anchored them against the wall. Despite the rain and cool colours, I feel the photograph has a warmth about it.

STEPPING STONES [p67]
Mel Foster
Location: North Yorkshire, England.
Camerawork: Ebony 45S, 2 seconds at f22, 0.6 hard ND grad on sky, Fujifilm Velvia 50.
Inspiration: I wanted to find a clean strong composition out of the naturally chaotic placement of the sandstone erratics. It is the distillation of the complex into something simple that speaks volumes and helps us see with fresh eyes.

WHITBY WAVE DETAIL [p69]
Melanie Foster
Location: North Yorkshire, England
Camerawork: Ebony 45S, 1 second at f32 1/3 second, Fujifilm Velvia 50.
Inspiration: I was drawn to the sinuous lines of the sandstone. It reminded me of the sculptural landscape of 'The Wave', but on a more intimate scale.
Technique: The previous evening I'd taken a wider view bathed in the glow of sunset. The following morning I returned to a more subdued light which I used to look for a simpler composition.

BRUSH STROKES IN THE SAND [p70]
Roger Longdin
Location: Budle Bay, Northumberland.
Camerawork: Linhof Technikardan 5x4,

210mm lens, 1 second at f22, Fujifilm Velvia 50 rated at ISO 40, 81B filter.
Inspiration: This image was made among the marram grass and sand dunes in Budle Bay. Very high winds had made the grasses scribe lines in the sand, which caught my attention. I like the curved flow of the grasses and the mini sand dune in the composition, together with late afternoon light glancing across the image.

COLOURS OF DECAY [p71]
Roger Longdin
Location: Chesil Beach, Dorset, England.
Camerawork: Linhof Technikardan 5x4, 210mm lens, 1/4 second at f32, Fujifilm Velvia 50 rated at ISO 40.
Inspiration: I came across this boat whilst on a Light & Land trip to Dorset in November 2006. It was amongst other old boats, beached or partially sunk in the lagoon behind Chesil Beach. The fact that it was still tied up, despite its unseaworthiness, was quite amusing. Also, the shape of the clinker-built hull complete with colourful lichens was very appealing. I positioned the camera so that the rope forms a triangular composition, 'anchored' by the stake in the bottom left of the image.

BARLEY AT SUNSET [p72]
Peter Garbert
Location: Brauncewell, Lincolnshire, England.
Camerawork: Nikon D70, 18-70mm lens, 1/40 second at f29, ISO 400, no filters.
Inspiration: I was attracted to a beautifully coloured sunset and cloudscape, but wanted to find a way to convey the 'feeling' of the scene in my image. I could not make a wider view of the landscape convey it effectively. Therefore I tried to simplify the scene by isolating a single stalk of barley and tried to link its curve to the curve of the cirrus cloud above, using the sunset colours as a backdrop.
Post-capture: RAW adjustments for contrast and saturation.

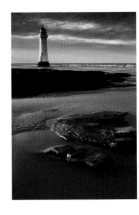

NEW BRIGHTON LIGHTHOUSE [p73]
Eli Pascal-Willis
Location: Merseyside, England.
Camerawork: Pentax K10D, 1/8 second at f16, 3 stop ND grad filter.
Technique: I went with an idea of the type of image I wanted, but it wasn't until I walked towards the pool that the scene unfolded. This was a turning point in my development; I felt I was able to use light to produce an image with my own style.
Post-capture: Photoshop levels and colour correction.

HAMPTON LUCY CHURCH [p74]
James Kerr
Location: Warwickshire, England.
Camerawork: Canon EOS 1DS, 34mm focal length, 1/50 second at f9.
Technique: An early morning trip resulted in this compelling shot of the church as it emerges from the water meadows. The low horizon and the brooding sky are as important in the success of this shot as the orange morning light.

DAWN NEAR HONINGTON [p74]
James Kerr
Location: Honington, England.
Camerawork: Canon EOS 1DS, 97mm focal length, 1/100 second at f9.
Inspiration: Day break in the autumn with the river mist still lingering creates atmosphere and mood.

BARFORD BRIDGE [p74]
James Kerr
Location: Bedfordshire, England.
Camerawork: Canon EOS 1DS, 146mm

focal length, 1/6 second at f20, ND grad filter.

Inspiration: Caught by the last rays of the sun's reflection, the stonework gently glows. A recent bypass has made this bridge almost free of traffic. I spotted the photographic potential when I was passing by in the car. I always make a note of potential shots to revisit in good light.

THE WINDMILL [p75]
James Kerr

Camerawork: Canon EOS 1DS, 200mm focal length, 1/60 second at f9, ND grad filter.

Inspiration: A windmill always makes an attractive motif to photograph. This one was difficult to get near and was located on top of a hill. I saw this as a potential shot as I was about to give up, as the weather was stormy, but with promising passages of sunlight piercing the sky. The silver birch trees really caught the light and, for me, made the picture.

Post-capture: In my images, adjustments in photo shop are kept to a minimum. I optimise exposure with levels and curves, use some local contrast enhancement and sometimes I will help a sky with a little colour, but only a touch.

ICELANDIC HOUSE [p76]
Simon Harrison

Location: Southern Iceland
Camerawork: Canon EOS 20D, 94mm lens, 1/320 second at f7.1, ISO 400.
Post-capture: Levels.

WAXHAM BEACH NORFOLK [p79]
Alan Reed

Location: Norfolk, England.

Camerawork: Sony DSC-V3, 1/160 at f4.5.

Inspiration: Taken late in the afternoon in mid-winter, with a low sun and near horizontal light. The texture and colour of the fine, dry sand looked like snow against the weather-beaten woodwork. I have sold several copies of this photograph. Buyers tell me they like its mood. I believe the composition is what mainly draws people into the image.

FENCE POST AND DUNE [p80]
Ian Laker

Location: Camber Sands, East Sussex, England.

Camerawork: Mamiya RZ67, 110mm standard lens, shutter speed not recorded, f4.5, Fujifilm Velvia 50, 0.6 Lee split ND filter, mirror lock-up, cable release, Manfrotto tripod.

Inspiration: Another example of indirect light reflecting from the sky into an area of shadow, giving it luminescence and creating bands of complementary blue and yellow. I also like the de-focused suggestion of human activity along the beach, giving a more truthful context to this image than the exclusion of anything not wholly natural.

SLATE AND SURF [p81]
Ian Laker

Location: Trebarwith Strand, Cornwall, England.

Camerawork: Mamiya RZ67, 50mm wideangle lens, 2 seconds at f32, Fujifilm Velvia 50, 0.6 Lee split ND filter, mirror lock-up, cable release, Manfrotto tripod.

Inspiration: I love it when the unexpected happens when looking for an image. In this case I wanted a sunset, but ended up with something far more representative of this part of the North Cornish coast. To me, the grey, stormy sky better complements the bleak slate coast. I love the thin glow of light hitting the horizon and the grey-blue (on the middle right) reflected up through the swell from the slate below, rather than from the sky above.

SPRING WOOD [p83]
Roger Creber

Location: Kew Gardens, London, England.
Camerawork: Nikon F70 camera, Nikkor 28-80mm lens, Fujifilm Velvia 50, aperture priority at f5.6, speed filter.

Inspiration: I love to immerse myself in the natural beauty of English woodland in the spring, and to show my individual response by producing colourful images with an ethereal and impressionistic quality. The aim was to use a speed filter, to achieve this.

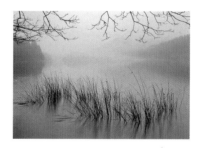

MISTY DAWN [p84]
Keith Urry

Location: Stanage Edge, Derbyshire, England.
Camerawork: Mamiya 645E, 35mm lens, 1 second at f22, Fujifilm Velvia 50, 2-stop ND grad filter.

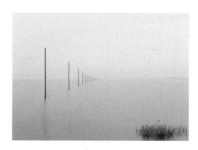

SILENCE, ST. CUTHBERT'S WAY [p86]
Mike McFarlane

Location: Lindisfarne, Northumberland, England.
Camerawork: Nikon D2X, 17-55mm lens at 55mm, 8 seconds at f16, ISO 100, 0.6 ND grad.
Technique: A long shutter speed with an inverted 0.6 ND grad gave the water a smooth look and darkened it down for this Zen-like composition.
Post-capture: Adobe Camera RAW: set white/black points and white balance. Photoshop CS2: RAW file blending,

sharpening with PhotoKit Sharpener, saturation enhancement with Velvia Vision, local contrast enhancement, final sharpening for output.

NORTHERN STORMS [p87]
Mike McFarlane

Location: Saltwick Nab, North Yorkshire, England.
Camerawork: Nikon D2X, 17-55mm lens at 20mm, 0.5 seconds at f11, ISO 100, 0.6 hard ND grad.

Inspiration: One of the things that I like about photographing in the landscape is watching the changes. Sometimes over years, sometimes over seconds, the landscape can change beyond recognition. Saltwick Nab in Yorkshire is a big plinth of slate with contrasting sandstone erratics dotted over it. I thought it looked bleak on my first visit and over the last few visits the wet weather and leaden skies have done nothing to change the scene. However, I have found a few compositions I would like to explore. I was looking for a pleasing composition involving the myriad of erratics.

Post-capture: Adobe Camera RAW: set white/black points and white balance. Photoshop CS2: RAW file blending, sharpening with PhotoKit Sharpener, saturation enhancement with Velvia Vision, local contrast enhancement, final sharpening for output.

THE MIRACLE OF LIFE [p89]
Mike McFarlane

Camerawork: Nikon D2X.
Location: Loch Mallachie, Cairngorms National Park, Scotland.

Inspiration: This rocky microcosm is one of the most amazing natural sights I have ever seen, showing just how hard nature perseveres to exist. Growing on this lump of granite in the edges of Loch Mallachie, in a wafer-thin scattering of compost, were a fir and a rowan or birch tree. Given the lack of ready nutrients, the competition with each other and the harsh climate, these trees are at least 3-5 years old. How can nature exist on so little? This rock really is a miracle of life. I had found this little cluster of life a few days before and wanted to make a photograph that showed something of how hard the existence of these trees was. Some fresh snow on the hills and a blue cast to the pre-dawn light gave the atmosphere that I needed.

Post-capture: Adobe Camera RAW: set white/black points and white balance. White balance cooled a little to increase the blue cast. Photoshop CS2: RAW file blending, sharpening with PhotoKit Sharpener, saturation enhancement with Velvia Vision, local contrast enhancement, final sharpening for output.

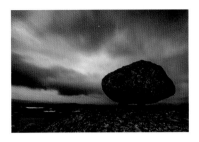

[NO TITLE] [p90]
Sylvestre Popinet
Location: Mountians of Norway.
Inspiration: This photograph is from a series on the mountains of Norway – a world of stones, water and sky. Shot at night, I like the movement of the clouds and the their contrast with that of the long-lasting erratic stone, speaking of ancient glaciers. I like the stone being so big and yet light, as if levitating.
Technique: Long exposure, no filter.
Post-capture: Two different shots, one exposed for clouds and the other for the stone, mixed in Photoshop.

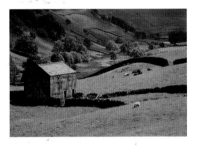

SWALEDALE FIELD BARN [p91]
Julian Parker
Location: Yorkshire Dales, England.
Camerawork: Canon EOS 5D, EF 70-200 f4 L series lens at 110mm, 1/50 second at f11, ISO 50, 2-stop ND grad filter, tripod.
Inspiration: It took some time for the light to come right and this frame was the best shot from this location.
Post-capture: RAW conversion and a slight boost in saturation.

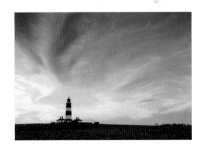

HAPPISBURGH LIGHTHOUSE [p92]
Ian Stacey
Location: Happisburgh, Norfolk, England.
Camerawork: Canon EOS 20D, 17-85mm lens at 28mm, 1/13 second at f16, ISO 100, 0.6 ND grad filter, tripod.
Inspiration: I had to wait over an hour

for the clouds to be in the right place, by which time the light had started to fade. I used a 0.6 ND graduated filter over the sky and this has also intruded into the lighthouse, making it a little darker than I wanted. I think I've just about got away with it though!
Post-capture: Minor levels and saturation adjustment in Photoshop.

SOUTHWOLD PIER [p93]
Ian Stacey
Location: Southwold, Suffolk, England.
Camerawork: Canon EOS 20D, 17-85mm lens at 44mm, 1/50 second at f16, ISO 100, 0.6 ND grad filter, tripod.
Inspiration: I wanted the sun to appear through the supports at the end of the pier. As I was getting ready to press the shutter button, a man came along the beach and just stood there, looking at the pier with his hands behind his back. He was obviously admiring the same scene as I was, but without a camera! At first I was a little annoyed and wanted him to get out of the way, but then decided that it would make a good image with him standing there. I think he gives scale and depth to the picture.
Post-capture: Minor levels and saturation adjustment in Photoshop.

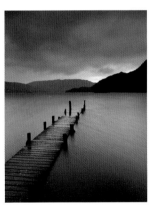

ANOTHER RAINY MORNING [p95]
Jonathan Horrocks
Location: Ullswater, Lake District, England.
Camerawork: Canon EOS 300D, 18mm lens, 20 seconds at f8, 3-stop ND grad filter.
Technique: This is a fairly typical example of what I would consider my style/vision. There is a strong leading line from the pier and I used a long shutter speed to capture movement in the water.

BLUE MOUNTAINS [p96-97]
Greg Covington
Camerawork: Pentax Spotmatic, SMC Takumar 300mm, Kodak Ektachrome P1600.
Style: I like the simplicity of the image, which was my aim.
Technique: The blue colour was how the film rendered the light. There was no filtration; it's a monochrome image of the shape of a mountain.

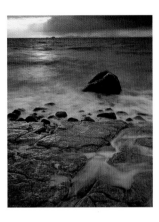

SHOWERS OVER UIST [p109]
Richard Childs
Location: Duntulm, Isle of Skye, Scotland.
Camerawork: Ebonsy 45SU, 135mm lens, 0.75 ND grad filter and 81A.
Technique: Pinned under a cliff at high tide, I had been trying to make an image across the bay, but as the sun appeared the cloud this image revealed itself.

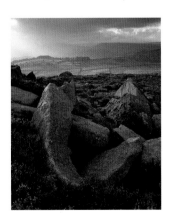

HOPE VALLEY FROM BURBAGE ROCKS [p110]
Nigel Halliwell
Location: Peak District, England.
Camerawork: Ebony 45SU, 1/2 second at f22, 0.6ND grad, Fujifilm Velvia 50.

Technique: I had walked along Burbage rocks, which are approximately 200 yards long, trying to find my foreground interest. My legwork finally paid off. It then took three visits over a week for the right light to finally make the picture work.

FALLING FOSS [p111]
Nigel Halliwell
Location: North Yorkshire, England.
Camerawork: Ebony 45SU, 10 seconds at f16, Fujifilm Velvia 50.
Technique: This image is all about reflected light. It was simply about positioning my camera for the best reflections and the only unknown was how the colours would mix with the long exposure.

SANDSTONE ROCK POOL [p112]
Nigel Halliwell
Location: Corrie, Arran, Scotland.
Camerawork: Ebony 45SU, 150mm lens, 3 seconds at f22, Fujifilm Velvia 50.
Technique: My dilemma was whether or not to include the pebbles at the bottom right. The reason I did was that otherwise the image would have been all one colour, with less impact, and lacking in texture. The pebbles also give a better sense of scale.

IMACHER POINT [p113]
Nigel Halliwell
Location: Arran, Scotland.
Camerawork: Ebony 45SU, 2 seconds at f45, Fujifilm Velvia 50.
Inspiration: As the sun started to set, this area of rock face started to take on another dimension. The shadowy and sunlit areas started to become far more defined and the rounded contours of the rock worked very well together, making it a very abstract image.

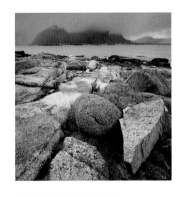

NEAR FLAKSTAD [p152]
Andy Latham
Location: Lofoten Islands, Norway.
Camerawork: Mamiya 7II, 43mm lens, 0.3 ND grad, Fujifilm Velvia 50.
Inspiration: It was early afternoon, and clouds drifted in to obscure a shaft of sunlight before I had a chance to set up this shot. I was drawn to the contrast

between the rounded and angular boulders. However, in the end I think the more subtle conditions fitted the subject matter. Dramatic light on the distant buildings would have taken attention away from the boulders. I hope to have conveyed some of the grandeur and timelessness of these fantastic islands.

HAUKELAND [p115]
Andy Latham
Location: Vestvagoy, Lofoten Islands, Norway.
Camerawork: Mamiya 7II, 43mm lens, f22, Fujifilm Velvia 50, 0.3 ND grad.
Inspiration: The incoming tide had covered the rock pool I had been photographing. The light was fading fast when I spotted these lovely rocks. There was just enough light left in the sky to let the distant headland stand out, with its dramatic cliff plunging towards the island. I hope I have both conveyed the sombre, imposing nature of the scenery and given a sense of the stillness and quiet at the end of a day.

'PICASSO' [p117]
Rupert Heath
Location: St Donat's, Glamorgan, Wales.
Camerawork: Ebony 45S, 90mm lens, 15 seconds at f32, Fujifilm Velvia 50, no filters.
Inspiration: In the darkness, a polecat? Later, at dawn, two ravens falling from the cliff top woods, gliding off their dark twiggy silhouettes, away into the chill grey sea mist, merging, dissolving, save their gentle invisible croak.

RIVER FLOW [p118]
Rupert Heath
Location: River Usk Powys, Wales.
Camerawork: Ebony 45S, 90mm lens, 5 seconds at f32, Fujifilm Velvia 50, 0.3ND hard grad.
Inspiration: The river's morning heron in its usual place, keen and tranced. Dippers and wagtails up and down the water, and the kingfisher hunting his regular haunt, while a buzzard's cry enhanced the peace.

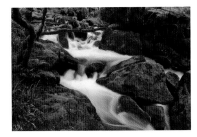

GOLITHA FALLS: MOSS, STONE AND WATER [p120]
Andrew Barnes
Location: Cornwall, England.
Camerawork: Canon EOS 20D, Canon EF 17-40mm f4 lens at 17mm, 1 second at f16, ISO 100, circular polarising filter.
Technique: I wanted to try to blur the flowing water, but also to include the wonderful deep green of the moss on the rocks, which the polariser helped to bring out. I think that this was also the first time that I had really thought about composition.

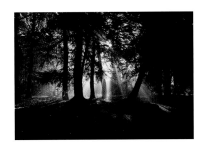

SUNRAYS, ELVASTON CASTLE [p121]
Wayne Brittle
Location: Derbyshire, England.
Camerawork: Canon EOS 10D, 17-40mm L series lens, 0.3 second at f22, Manfrotto tripod.
Technique: I waited while the morning mist slowly burned away in the rising sun. I knew that at some point I would have the opportunity to shoot the suns rays and once they appeared I tried to capture the atmosphere of the occasion.
Post-capture: Adjustments to levels and unsharp mask filter in Photoshop.

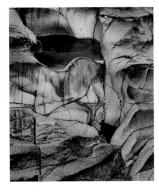

RIVER ROCK POOLS [p122]
Jon Brock
Location: Glen Etive, Scotland.
Camerawork: Linhof Technikardan, 150mm lens, Fujifilm Provia 100, no filters.
Technique: This image was the culmination of several months of work, in which I looked for distinctive and strong patterns in the landscape. Most of these images didn't work, but it trained me to spot patterns more easily. Having seen this one, the challenge was how to capture it without falling twenty feet into Glen Etive. It took quite some time to set up. For me, the colour in the rock, contrasting with the greens, really makes the image.
Post-capture: Scanned with an Epson Perfection V700.

ROWAN TREE FALLS [p123]
Jon Brock
Location: Isle of Skye, Scotland.
Camerawork: Wista DX, 240mm lens, Fujifilm Velvia 50, no filters. Umbrella courtesy of Joe Cornish.
Inspiration: On a trip to Skye with Light & Land, we came across this fabulous waterfall almost by accident. It was pouring with rain and the river had flooded so that the planned walk was not accessible. A stretch of the legs revealed this amazing location. A friend of mine made a stunning picture in his own style that hangs with this one on my kitchen wall. I selected a more compressed viewpoint that I hope manages to convey a sense of depth and the wonder of the place.
Post-capture: Scanned with an Epson Perfection V700.

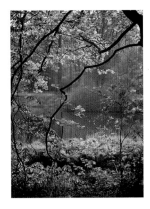

THE BLISS OF SOLITUDE [p124]
Phil Mann
Location: Arley, Cheshire, England.
Camerawork: Mamiya Pro TL, 150mm lens, Fujifilm Velvia 50, no filters.
Inspiration: What appeals to me about this image is that it is essentially a picture of nothing in particular. There is no real subject, just a glimpse through the trees and yet, to me, it suggests a feeling of peace and serenity. Of course I know how peaceful it was at the time, but I certainly hope it has that effect on the viewer.

SCULPTURED, IMACHAR POINT [p125]
Phil Mann
Location: Isle of Arran, Scotland.
Camerawork: Mamiya Pro TL, 80mm lens, Fujifilm Velvia 50, 81A filter.
Inspiration: I get a huge amount of pleasure in 'finding' images where others might not. Here, however, the tide was on the way out and I wasn't quick enough to capture the water on the rock. I feel this would have improved the picture, but I am still fairly happy with the result.

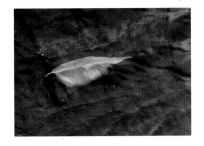

LEAF, MIDDLE EMERALD POOL [p127]
Adam Pierzchala
Location: Zion Park, Utah, USA.
Camerawork: Nikon F100, Nikon AF 28-105mm lens at macro setting, shutter speed not recorded, f22, Kodak Elitechrome 100. No filters.
Inspiration: Looking through the lens, I saw the wonderful play of colours. There was the pale blue leaf complementing the greenish patch of rock and pink reflections on the water cascading over the leaf and harmonising with the reddish rock. The patches lit by the sun added further interest. It was just beautiful.

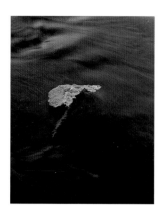

ROCK AND ICE [p128]
Guy Aubertin
Camerawork: No details supplied.
Style: Part of my developing style is to try and be 'quiet' in my image-making. I also, on occasion, strive to give the viewer something that requires concentration to understand what is going on. I don't subscribe to the view that images need to be effortless to look at. When making images out of the unusual, you need to engage the viewer. This melting piece of ice, clinging to its rock looks like something from another dimension. The very dark background emphasises the blue-ish white of the ice. The splash of gold in the background from the reflected light just allows the viewer enough information to place the image – at least that's the theory!

RED AND WHITE [p131]
Guy Aubertin
Camerawork: No details supplied.
Inspiration: My vision was simple but the execution was complex. I wanted to pay homage to these stunning rocks, that I had seen nowhere else. However, on their own, they failed to shine. The red seaweed provided a pinch of drama and the black separation around the smaller stones conveyed depth. The trick was to not over-expose the rocks and to make use of the grey sky overhead. If it had been blue, Fujifilm Velvia would have emphasised that particular tone and the whiteness of the rocks would have been lost.

BEAUTIFUL GATEWAY [p132-133]
Quentin Brown
Location: Coyote Buttes, Paria Canyon wilderness, Arizona, USA.
Camerawork: Sigma SD9, Sigma 18-125mm DC lens at 18mm, 1/250 second at f6.7.
Technique: This was simply my personal response to this powerful place. I was really taken by the swirling, flowing forms of the rocks with the amazing patterns and

colours that followed their contours. The strong visual channels they formed at this point led me into the greater landscape beyond. I felt this added element would give the image enough interest to take it beyond a simple study of shape, colour and form. I also wanted to create a very large print so that all the details could be appreciated.
Post-capture: Manual stitching of six shots to form a panoramic image, heavy colour and contrast adjustment, plus dodge and burn.

SEA OF BARLEY [p134]
Nick McLaren
Location: Bowland, Scotland.
Camerawork: Ebony 45SU, 150mm lens, 2 seconds at f22, Fujifilm Velvia 50, no filters.
Inspiration: I had been hoping to find a more open landscape than this field, but to no avail. These patterns in the barley only appeared in the soft light once the sun had set. I was trying to communicate rhythm and movement here and I think it works quite well. The flattened barley and the ears take on the appearance of a wave, hence the title. Using a high viewpoint and a little bit of rear tilt helped to emphasise the flow.

MOSS ON WALL [p136]
Colby Chester
Location: Seattle, Washington, USA.
Camerawork: Canon Powershot S40, Canon 7.1-21.3mm f2.8-f3.5, 1/100 second exposure.
Inspiration: We live in an elevated

area above the lakes that define Seattle's boundaries. I walk through the neighbourhood daily, often looking for things I haven't noticed previously, and photographing them when they are particularly striking. So it was one morning, when I noticed these geometrics of rocks and masonry abutting a neighbour's garage. I had only a small point-and-shoot Canon camera with me, but it was adequate for the image I wanted. The rich layer of moss and tiny expressions of life between the rocks suggested a landscape in miniature. The juxtaposition of the rocks and masonry triggered something almost Druidic in me, reminding me of the great stoneworks of ancient times. But it was ultimately the insistence of nature in the form of the verdant moss that made this image call out to me.
Post-capture: Contrast boost and hue boost.

SILENCE AND LIGHT [p137]
Colby Chester
Location: Queen Charlotte Island, British Columbia, Canada.
Camerawork: Nikon D70, Nikon 18-70mm f3.5-25mm, 0.39 second at f5.6.
Inspiration: A few years ago, I went on a kayak adventure with five others and a guide in the remote Queen Charlotte Islands off the coast of British Columbia. We trekked into a beautiful old-growth spruce forest. Within fifteen feet of the beach, our surroundings transformed abruptly from the intense heat of a July afternoon to the cool silence of a hushed, canopied wilderness. We followed our guide to a small, translucent stream and dipped our hands into its bracing waters. When the others had moved on, I lingered until the waters were still again, and in the silence of that solitude, I asked for an image. This was the result.
Post-capture: Contrast boost, some curves manipulation.

RED AND GREEN [p138]
Christos Andronis
Camerawork: Canon EOS 350D, 94 mm focal length, 4 seconds at f16, ISO 100, polarising filter.

Inspiration: This photograph is mostly about colour. I like its simplicity, its colour juxtapositions and simple shapes.
Post-capture: Levels, curves and sharpening, all in Photoshop.

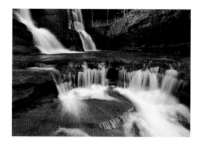

PWLL-Y-WRACH WATERFALL [p141]
Steve Gray
Location: Brecknockshire, Wales.
Camerawork: Nikon D70s, 11-18mm lens, 1/3 second at f20, ISO 200, polarising filter.
Style: This is the most recently taken image from my submission. Perhaps it reflects a growing understanding of how to identify and capture a successful image in a complicated landscape.

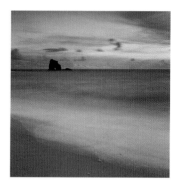

THURLESTONE BEACH [p143]
Tony Cobley
Location: South Devon, England.
Camerawork: Canon EOS 5D, 24-105mm USM lens at 35mm, 30 seconds at f22, Lee 0.9 ND grad and Lee polariser filters, ISO 100.
Technique: Switching to digital, I visualised this evening image being cropped to square format at the time of shooting, working on diagonal lead-in lines to the key elements. A long shutter speed produced a dreamlike motion. The water's movement became a third dimension; something David Ward would call 'space mutated by time'.
Post-capture: RAW file processed with contrast and saturation boosted. Then I added magenta to the sky and sea using a curves adjustment layer, and added a layer mask over the sand to produce colour contrast. The sand was brightened with a masked curves adjustment layer.

Acknowledgements

We want to offer our sincere thanks to everyone who has submitted images for possible inclusion in this book and who entered into the discussion about developing vision and style. The book would not have been possible without these people having the courage to share their views and, of course, their images. They have contributed greatly to the exchange of ideas upon which creative photography relies.

Andrews, Chris	35	Heath, Rupert	117-118
Andronis, Chris	138	Hollister, Adrian	30-31
Aubertin, Guy	128-131	Holroyd, Richard	46-47
Baker, Nigel	22-25	Horrocks, Jonathan	95
Baldwin, Angela	9	Isakova, Nadia	65
Barkway, Julian	40-41	Karry, Peter	4-5
Barnes, Andrew	120	Kerr, James	74-75
Brittle, Wayne	121	Kroese, Janneke	42-43
Brock, Jon	122-123	Kuzminski, Tamara	21
Brown, Michael James	36	Laker, Ian	80-81
Brown, Quentin	132-133	Latham, Andy	152-153
Brown, Ross	37	Lewis, Sean	38
Chester, Colby	136-137	Longdin, Roger	70-71
Childs, Richard	109	Mann, Phil	124-125
Cobley, Tony	143	Marsch, Paul	44-45
Coffey, Hazel	48-49	McFarlane, Mike	86-89
Covington, Greg	96-97	McLaren, Nick	134
Cox, James Michael	32	Parker, Julian	91
Creber, Roger	83	Popinet, Sylvestre	90
Douglas, Pat	51	Pierzchala, Adam	127
Foster, Melanie	66-69	Reed, Alan	79
Gallagher, Paul	26-29	Stacey, Ian	92-93
Gray, Steve	141	Sunderland, Mark	7
Griffiths, Michéla	50	Urry, Keith	84
Halliwell, Nigel	110-113	Wilgen, Frans R. van	53
Harrison, Simon	76		

If you want to find out more about any of the participating photographers, individual website details can be found at www.developingvisionandstyle.com

Conclusions about vision and style?

I WONDER WHAT EACH OF US has gained from this discussion about developing vision and style? Has it helped clarify our photographic viewpoint? Or maybe it has got us to question our approach, perhaps inspiring us to think outside of our comfort zone (as it has done for me) when taking the next step on our creative journey.

Reading the submissions to *Developing Vision and Style,* and the comments attached to them, it was evident that every photographer (including the three named authors) was challenged in one way or another by having to address the vision and style questions (on page 8). Photographers often say they can't write, claiming that images are their chosen means of expression. The latter is true, but I like to think that *DV&S* proves they can write with equal passion and great insight. Photographers have a good sense of what motivates their work and a keen desire to develop their self-expression, but how often do we get – or make – the opportunity to express our thoughts in words, as people have done here? Writing helps clarify our creative purpose and direction, as many of the participants remarked. Every photographer is the person best 'qualified' to write about their approach to photography.

It is sobering to think that once such thoughts are committed to print there is no going back. With a book there is no click of a mouse to delete 'mistakes'. Committing oneself to paper is as good as carving in stone – it's there for keeps. A book marks a stage in one's creative journey and is all the more powerful for it. Well done to all those who took part. I wonder what the participants' thoughts on vision and style are now?

Eddie Ephraums

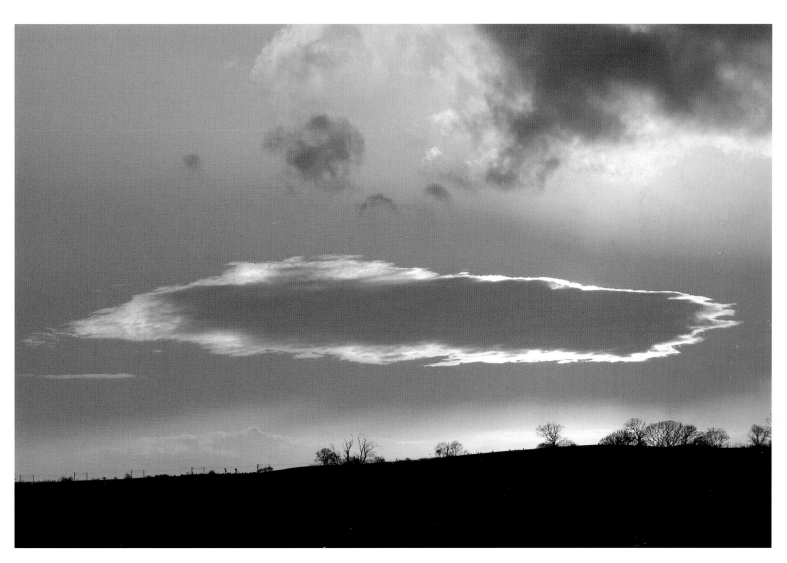

Alnmouth sunset
Eddie Ephraums

First published in 2007 by Argentum, an imprint of Aurum Press Limited, 7 Greenland Street, London NW1 0ND

A catalogue record for this book is available from the British Library.

Argentum softback edition
ISBN-10 1 902538 49 8
ISBN-13 978 1 902538 49 5

6 5 4 3 2 1
2012 2011 2010 2009 2008 2007

Envisage Books hardback edition
ISBN-10 0 9541011 1 1
ISBN-13 978 0 9541011 1 4

Developing Vision & Style edited and designed by Eddie Ephraums.
Editorial assistance – Melanie Foster, David Clark and Anita Soekerno.
Printed in Singapore by CS Graphics.

An Envisage Books Slipcased Limited Edition and a Collector's Edition with a choice of original print are available at www.envisagebooks.com

For information about Light & Land tours and workshops, go to www.lightandland.co.uk